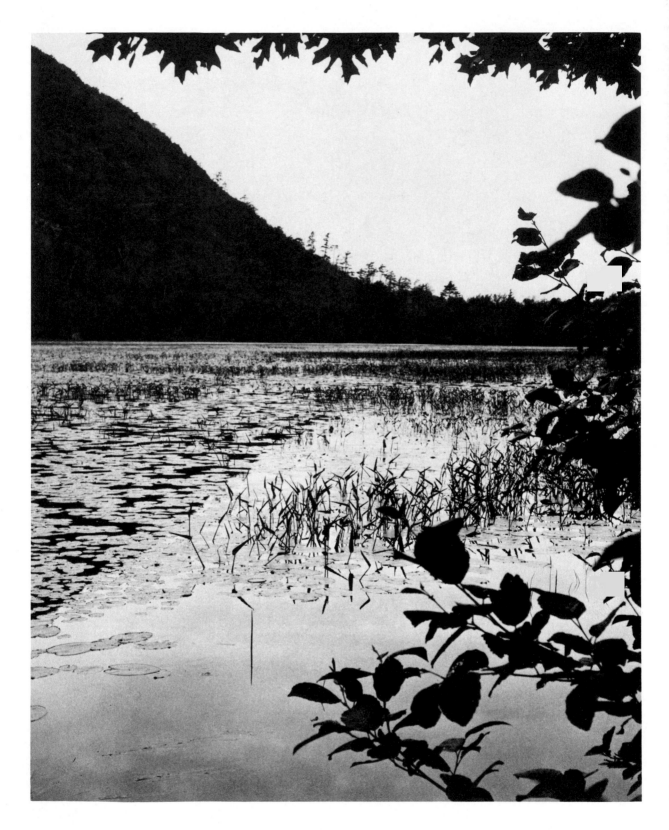

Pond, Acadia National Park, Maine. (Rolleiflex; MS pan)

Phil Brodatz

LAND, SEA AND SKY

A PHOTOGRAPHIC ALBUM FOR ARTISTS AND DESIGNERS

Dover Publications, Inc., New York

To Judy

ACKNOWLEDGMENTS
A special thank you to M. R. Bennett for her inspiration, encouragement and editorial assistance, and to Ed Manak of the National Hurricane Center, University of Miami, Coral Gables, Florida.

Published in Canada by General Publishing Company, Ltd., 30 Lesmill Road, Don Mills, Toronto, Ontario.
Published in the United Kingdom by Constable and Company, Ltd., 10 Orange Street, London WC 2.

Land, Sea and Sky: A Photographic Album for Artists and Designers is a new work, first published by Dover Publications, Inc., in 1976.

This book is sold with the understanding that illustrations may be reproduced for advertising or editorial purposes without payment or special permission. Such permission is, however, limited to the use of not more than six illustrations in any single publication. Please address the publisher for permission to make more extensive use of the illustrations in this volume. The author will appreciate the usual credit line, indicating title and publisher, although such a credit is not a requirement for use.

The author can supply photographic prints of any of the illustrations in this book for $20.00 each. Please address order with remittance to: Phil Brodatz, 100 Edgewater Drive, Coral Gables, Florida 33133.

International Standard Book Number: 0-486-23249-2
Library of Congress Catalog Card Number: 75-30178
Manufactured in the United States of America
Dover Publications, Inc., 180 Varick Street
New York, N.Y. 10014

INTRODUCTION

An exciting journey

The photographs on these pages deal with the interplay between Nature's elements. Light on water, wind on water, water on stone, water as steam, water as clouds, the effects of wind and rain, heating and cooling on earth.

Come with me on an imaginary trip. Our first view of planet Earth will be from 23,000 miles out in space. Earth is a revolving ball enveloped in a hazy atmosphere, subject to light and darkness. The angle of the earth in relationship to the sun governs our seasons of the year . . . spring, summer, autumn and winter.

There are various layers of air currents moving rapidly. These will be hard to see, but we can see clouds of moisture driven by these winds, and their effects on the clouds. There are broad movements on wide fronts, with snow. There are circular movements, familiarly called hurricanes. There is lightning and thunder.

We can hesitate for a moment and consider the strength and power of these forces doing their thing on that rotating ball we call Earth.

Let us continue to pretend that we are on a tour, and I shall play the part of your tour director. Instead of guiding you by a lengthy explanation and discussion of natural phenomena, I shall use my special cameras and lenses. We will look at a scene or at an effect, then I shall stop the movement and hold it there for you to study in depth. You can see with your eyes, you can see with your mind, you can hear the sounds, you can feel the weather and sense the excitement or elation of the moment.

Satiated, you can continue, turn the page, stop and study the next scene, then travel on. This is the game we shall play.

From our spaceship, where we travel at 23,000 miles above Earth, we will transfer to a jet plane and fly at 35,000 feet above the surface of the Earth. At this height we are just above the weather, and we can look down. You will see the textures and patterns of the clouds; look carefully and you will see the sun's rays making cloud shadows on the sea and earth. Should we have to fly through the clouds, fasten your seat belts. You will feel the power and force of the winds buffeting our huge plane as though it were a toy.

After flying just in and over the cloud formations, we will stand on Earth and take a long look upward.

The most prevalent complaint about tour directors is that they call, "Step along, the bus is leaving," before you can read your exposure meter, set the focus and adjust your camera. On this trip you will set your own pace. Our vehicle will wait for you even if

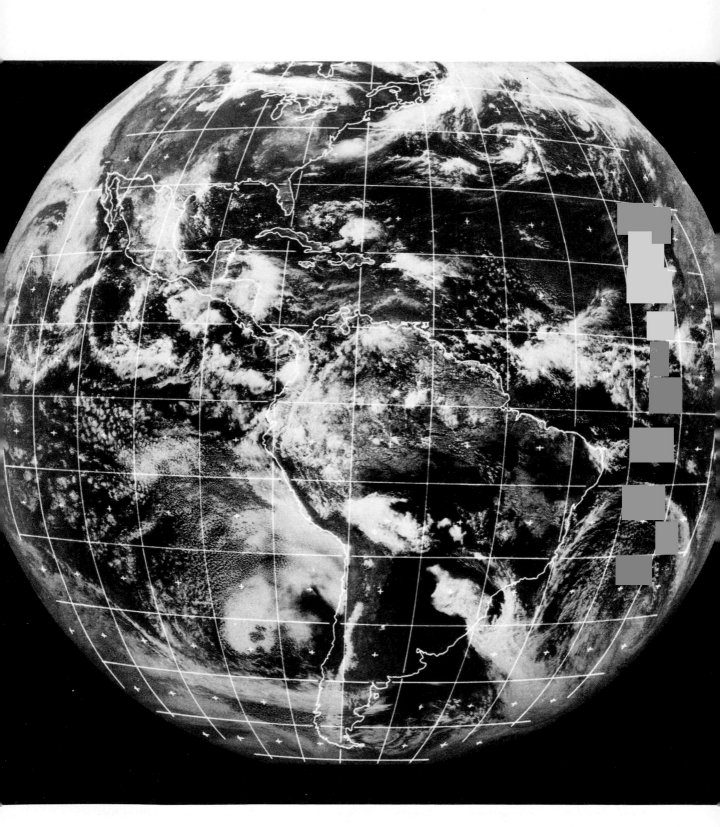

Satellite photograph, Western Hemisphere.
(Courtesy of National Hurricane Center, Miami, Florida)

you are a slow reader. Study the scenes as long as you wish, relish them, feel the wind, smell the perfume in the forest air, hear the silence in the redwood grove. You can come back again and again for another look. We promise to hold these precious moments for you.

We will spend time on the beaches and waterways of Florida, in the mountains of St. Thomas, and in a rain forest at St. Croix in the Virgin Islands. We shall fly to Maine and tour Bar Harbor, Acadia National Park, Mount Desert Island, and the Bald Head Cliffs at Ogunquit.

Each place which we will visit has a character, color, flavor and uniqueness all its own. Each is so distinctive that once having been there, it will never be forgotten.

Leaving Maine, we go across mountains to New Hampshire, Massachusetts, Connecticut, through upper New York State and Pennsylvania. Here we find waterfalls, country streams, lakes, ponds, valleys, farms, fresh air and a sense of peace.

Leaving these tranquil scenes, we will fly across the country to Colorado — the Black Canyon of the Gunnison and Rocky Mountain National Park. This is "big" country. The expanse is immense, the mountains and sky on a vast scale. Some say this part of the world gives them the sensation of being very small and insignificant.

Let's spread our arms wide and gulp in quantities of fresh, clean air. Coming from a life spent in small, expensive, compartmentalized spaces of concrete, glass and steel, when we suddenly find ourselves in unlimited space, we undergo another sensation—intoxicating, overwhelming. What a challenge to the photographer! How to capture this enormous environment and emotional experience? We record with our wide-angle lens, and we present these images on double-page spreads, large enough for us to immerse ourselves in.

We next cross the Continental Divide, and head south and west to the Grand Canyon. Here are more reminders of the powerful forces of Nature. Time, wind, rain, ice and snow eroded and carved stones and curved the rivers. We learn that Nature's strength is far mightier than any that man can create in his laboratories and factories.

Next we take a slight detour to Joshua Tree National Monument. This is high desert country; very dry, very low humidity, with temperatures upwards of 98°F, and a strong, balmy breeze. This gives us another strange, exhilarating feeling. From a promontory we can look southwest for miles to the marvelously fertile Imperial Valley. The soil's great richness is the result of the wind and rain's having washed down quantities of minerals and nutrients from the mountains, a rich bed for the growth of fruits and vegetables.

Now we shall drive north up the Pacific Coast Highway, through Big Sur, Point Lobos and Muir Woods. We will listen to the sound of the wind sighing through the forests and to the booming of the surf. Only in the midst of a redwood grove will we experience true silence. Standing in a grove, looking into a nave of giant redwood trees, we will have a strange sensation akin to reverence, as though we are in a great cathedral, feeling the presence of God. Bless the thoughtful individuals with the courage and foresight to set aside these oases from our "hurry-up" civilization.

Point Lobos is a rocky retreat on the edge of the Pacific. Here grows the Monterey cypress, a tree which represents a miracle of survival. Growing on rock, with a bare minimum of soil, it is constantly beaten and battered by the onshore winds, which twist and turn it into a strange, exotic shape. When it finally dies it presents us with a fascinating silhouette. Comes the sunset, it is impossible to drag ourselves away from the color and shadows playing a dance on the ground.

How fortunate we are to have the opportunity to see God's country at such close hand; to have the mentality to bridge the eons of time and visualize what time and force can do to cut gorges and canyons and raise mountains. How blessed to have the senses to feel the radiant energy of the sun and experience the coolness when the sun dips below the horizon.

On technique

When dealing with nature as a subject, black and white film can often interpret a scene magnificently. The strength in a black and white photograph lies in its ability to emphasize form by tonality and contrast. However, there are moments during sunrises and sunsets when colorful hues fill the land, sea and sky with radiant light and reflections. At these times color film is a must.

Martin Husing, a dear friend, photographic technical rep, competent photographer and P. S. A. judge, while looking at my prints, would shake his head and comment, "You break all the rules, but you have your own way with processing and chemistry. I like them."

Is it possible to develop a special sense of judgment to be able to juggle the variables of film, chemistry and printmaking?

A built-in computer?

It must be so. And add to this a smidgeon of personal taste and you come up with a highly individual result. If you give the same negative to three expert printmakers, you will receive in return three different prints, each with the added touch of the maker.

Choice of Camera. Most of the photographs in this collection were taken with a twin-lens 6 x 6 Rolleiflex. The Brooks Veriwide was used for some of the wide photographs, and a Sinar 4 x 5 with 65 mm. and 90 mm. Super Angulon lenses was used for the western scenes.

These pictures were taken over a period of years, and the mode of travel had a strong bearing on my choice of cameras and accessories. Crossing the United States on a picture-taking trip by car, the clothing was placed in a rooftop carrier, and the trunk was full of heavy tripods, view cameras and lots of roll and sheet film.

I discovered that the mainstay camera on this trip was the twins-lens 6 x 6 Rolleiflex, ideal for maneuverability among trees and near streams. The 4 x 5 Sinar, while being a comparatively lightweight view camera, was still slow and clumsy to set up and operate. At a picture spot one day, a small child watching me set up the Sinar asked if it was "break-

down parts." Not really, but it looked that way.

Now, I mostly fly, and my choice of cameras is based on portability and weight. The twin-lens Rolleiflex is still the "No. 1 camera," and the Brooks Veriwide is right alongside of it. I have the earlier model of this limited edition; small, compact, lightweight, and it takes seven exposures on a 120 roll with a disproportionate format—$2^{1}/_{4}''$ x $3^{1}/_{2}''$.

In the captions accompanying the photographs, I have indicated the camera used for each shot, as well as the film and filter (if any). The Rolleiflex twin-lens reflex, 6 x 6 cm., is designated simply as Rolleiflex. When the Rolleiflex twin-lens reflex, 4 x 4 cm., was used, I have made special note of it. Veriwide refers to the Brooks Plaubel, 47 mm. Super Angulon lens, with $2^{1}/_{4}''$ x $3^{1}/_{2}''$ film format. Finally, the Sinar 4 x 5 universal view camera, accommodating a variety of lenses of different focal lengths and a number of film sizes via adapters, is also listed in some of the captions.

Stable Support. For the Rolleiflex, the neck strap was used as the principal support for the close scenes, a medium tripod for the distant views. I have not as yet found a lightweight, portable, compact tripod. The Time-Life photographers use vise grips with attached tilt heads. I am now exploring the potential of the Leica table tripod, and a colleague has shown me how to use it as a shoulder brace.

A rigid support becomes most important when working with wide-angle cameras. Leveling the camera horizontally and vertically is a must, particularly for streets and buildings. With clouds and sky, we can take some liberties.

Extreme wide-angle lenses of 100° plus give some very interesting perspectives. Used with control, we can produce exciting images. Test yourself; see if you can tell which is the normal view and which the wide-angle in the following photographs.

Film and Chemistry. Hyfinol is a film developer I have worked with for the past fifteen years. It is consistent, dependable, and it treats me kindly. Then it's merely a matter of matching film characteristics with this vigorous de-

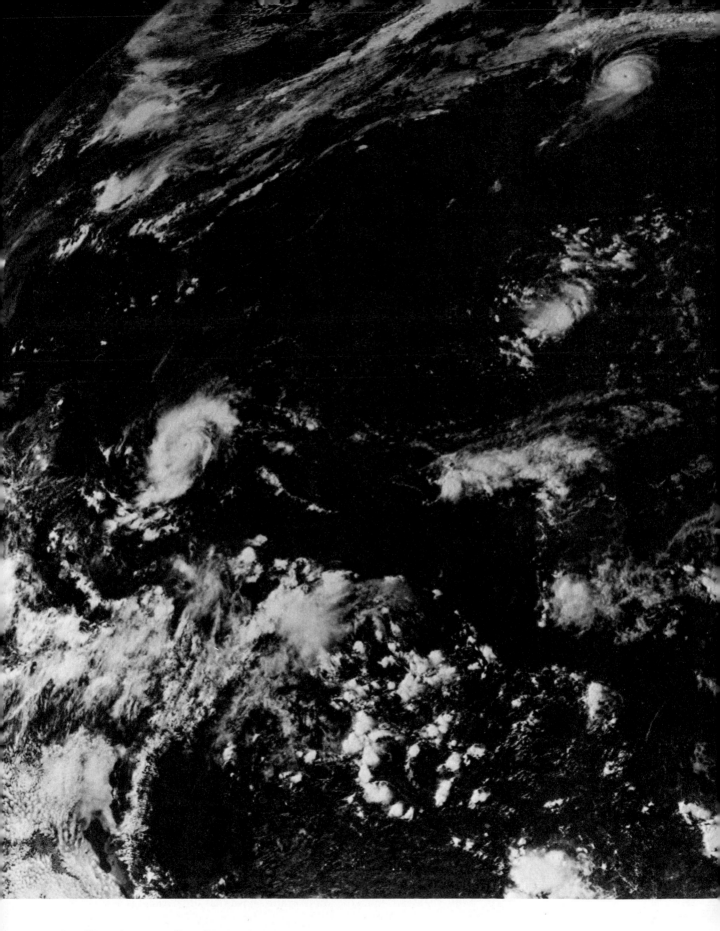

Satellite photograph, Atlantic Ocean.
(Courtesy of National Hurricane Center, Miami, Florida)

veloper and coming up with a negative of a density suitable for my enlarging techniques.

Since I can use a richer negative than most photographers, given a fully exposed and fully developed negative with detail in the shadows I can produce a long-scale print with deep, rich blacks, excellent highlights and full detail in between.

Most of the film I use is either GAF Versapan or Kodak Tri-X, but I also occasionally use Gevaert infra red. Versapan matches well with the Hyfinol developer, starting out as a low-contrast film and gaining character, contrast and crispness. Kodak Tri-X reacts in a similar fashion.

My rain forest photographs are here thanks to the use of Tri-X. The light is quite dim in the depths of the forest. The speed and light-gathering ability of this remarkable film saved the day.

Some of the photographs on these pages were printed from Gevaert infra red 120 film. My trial and error approach with this film has resulted in some poor pictures and some spectacular ones. I need infra red for haze cutting and other interesting effects; therefore I'm now spooling 70 mm. Kodak bulk film and photographing with a specially adapted camera, compromising size and weight for need, of course.

I'm afraid to open Pandora's box with a discussion of the relative merits of 35 mm. film. Yes, infra red is available in 35 mm., but for my purposes 2¼" width is a minimum.

In the picture captions, I have employed some abbreviations to indicate the film used. MS pan refers to medium-speed panchromatic films such as Eastman Kodak Plus-X or GAF Versapan. HS pan denotes a high-speed panchromatic film such as Eastman Kodak Tri-X. Infra red is either Eastman Kodak infra red or Gevaert infra red.

On Printmaking. Fortuitously, I did a stint at the Time-Life laboratory in New York City, and it served to point the direction of my career and life.

At Time-Life they had a standard Omega D II enlarger, equipped with 250-watt bulbs with rheostats to step down the voltage, and a by-pass switch. Simple enough in theory, in practice it worked like a dream, making it possible and practical to print very rich negatives. This enlarger simply has more horsepower than conventionally built ones, and affords infinitely more control.

For printmaking, the Time-Life lab used a two-tray developer process. One tray contained the usual developer mixed with two parts of water; the other tray contained the opposite formula, two parts of developer to one part of water—a rather powerful solution. In use, the print is first fully exposed under the enlarger and then placed in the stronger developing solution where the paper is nudged into building up rich black tones. Then we shift to the normal strength developer to bring out the grays and whites. The control is subtle, with lots of possible variants.

Filters. For this type of scenic photograhy, we need just a few filters—a Polaroid (Pola screen), a #22 orange, and a #25 or #29 red. The Polaroid substitutes for the #8 light yellow or the #12 medium yellow, and has the added ability to darken water as well as sky. This filter is a must for most of midday. The #22 orange darkens the blue sky, and the #25 or #29 red blackens it. The darker we render the blue sky, the more we accent the white clouds. To determine the proper exposure, read the value on the white clouds. You can compute the filter factor, or you can take your reading through the filter.

Picture-Taking and Printmaking. In time past, a photographer used to coat a glass plate, photograph a scene by exposing the plate, rush back to the darkroom, process the fragile image (subject to dust, temperature and fog), and then make his own print by exposure to daylight. I have an album of scenes of Madeira, Natal and South Africa, photographed in 1881–1882. These photographic prints speak highly for the craftsmanship and skill of these primitive photographers; primitive only in the sense that their cameras and equip-

ment were rudimentary and unsophisticated compared to ours.

Today our films are superbly manufactured and our cameras are marvels of technology. Our prints are mass-produced in photofinishing factories.

Somehow, something has been lost between then and now. The picture-taker's personal dedication and application to the process, with all its built-in obstacles, somehow made him a more creative photographer.

We have tended to separate the skills; most picture-takers are no longer also picture-makers. But for the photographic artist, the print is the objective. He needs to visualize the image, photograph it and process it to completion. There is a soul-satisfying joy in completing a well-done project. Picture-takers who delegate their printmaking to others dilute or alter their final print, and fail to achieve this sense of fulfillment.

A photograph is a reflection of the personality of the maker.

LAND, SEA AND SKY

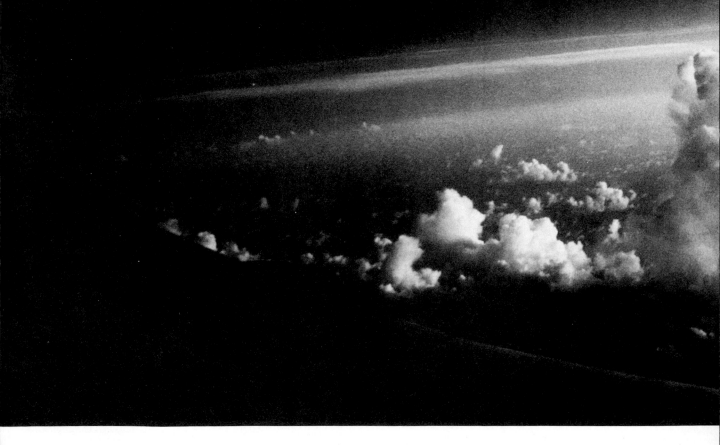

Horizon at 35,000 feet above Earth.
(Sinar wide; MS pan; #29 red)

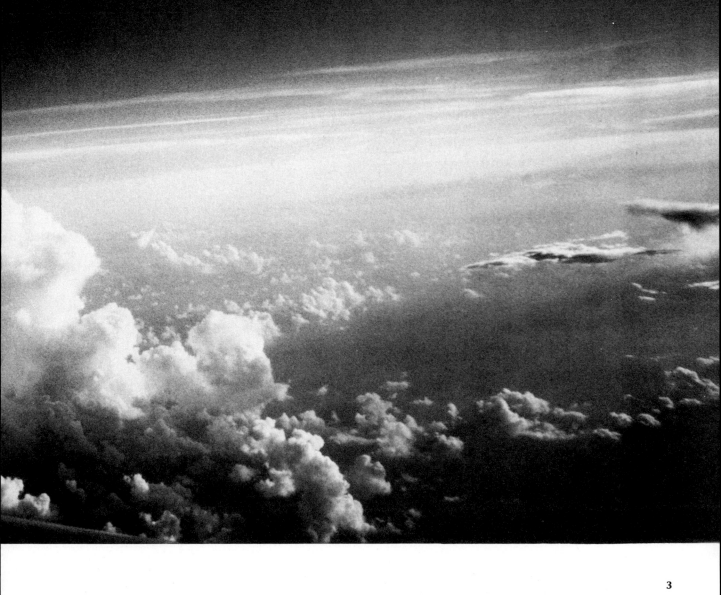

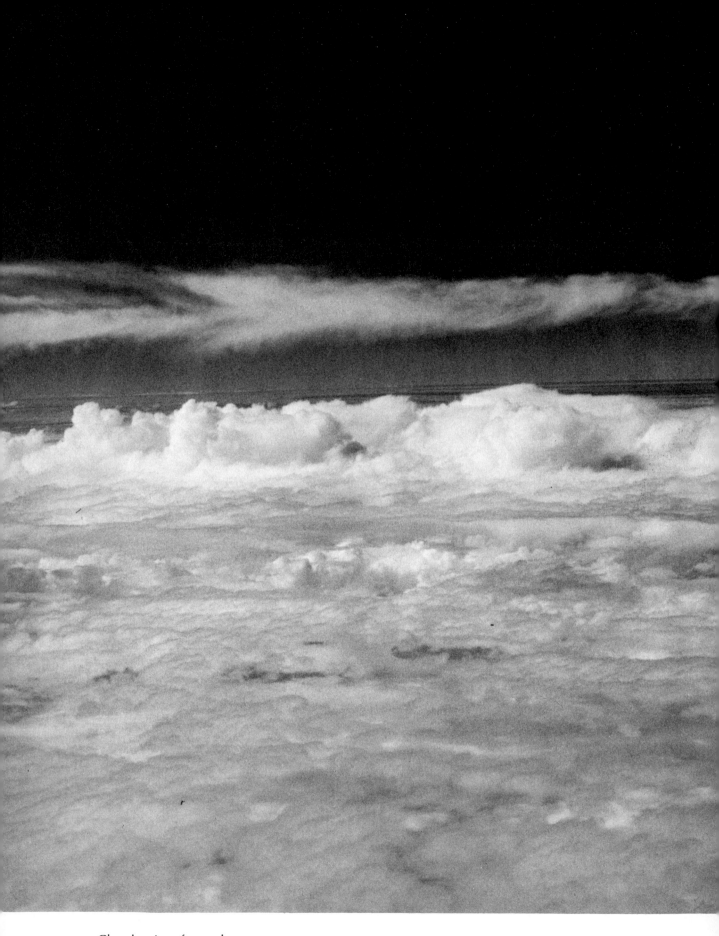

Clouds, view from above.
(Rolleiflex; MS pan; #22 orange)

4

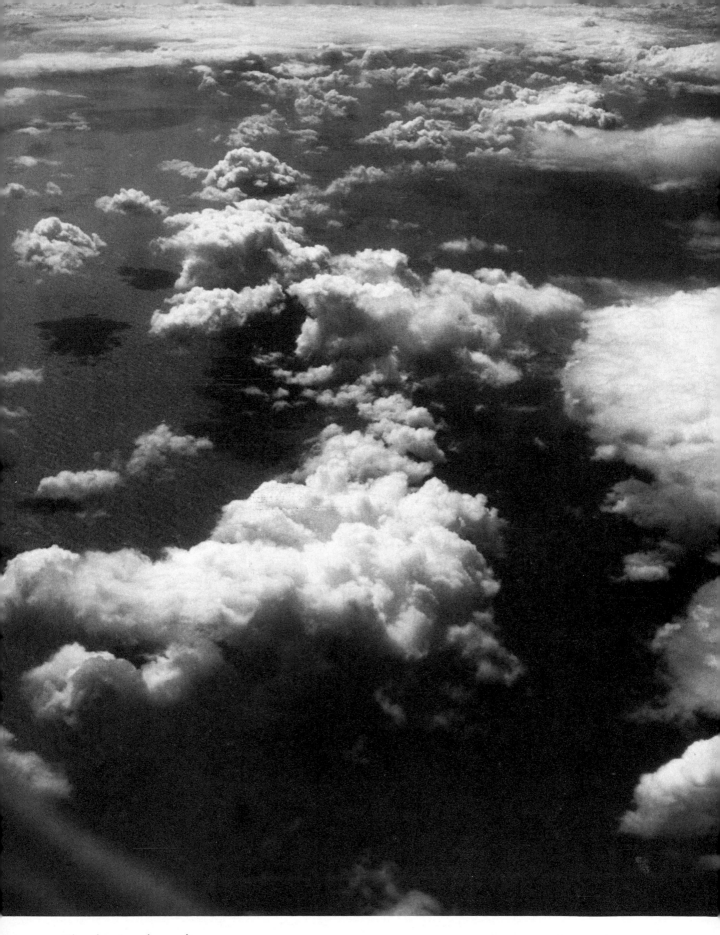

Clouds, view from above.
(Rolleiflex; infra red; #29 red)

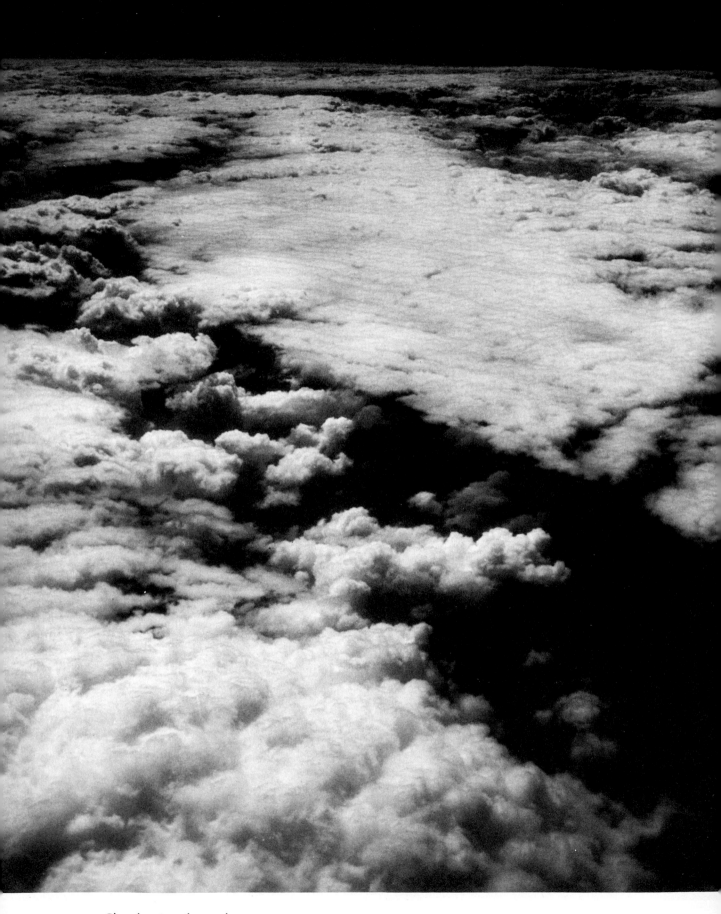

Clouds, view from above.
(Rolleiflex; infra red; #29 red)

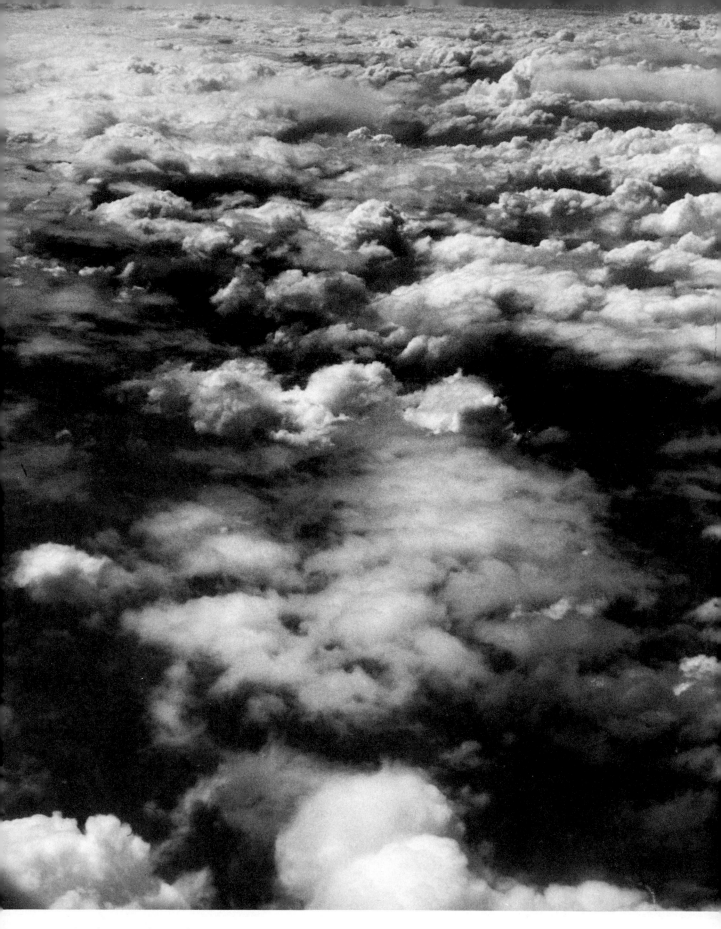

Clouds, view from above.
(Rolleiflex; infra red; #29 red)

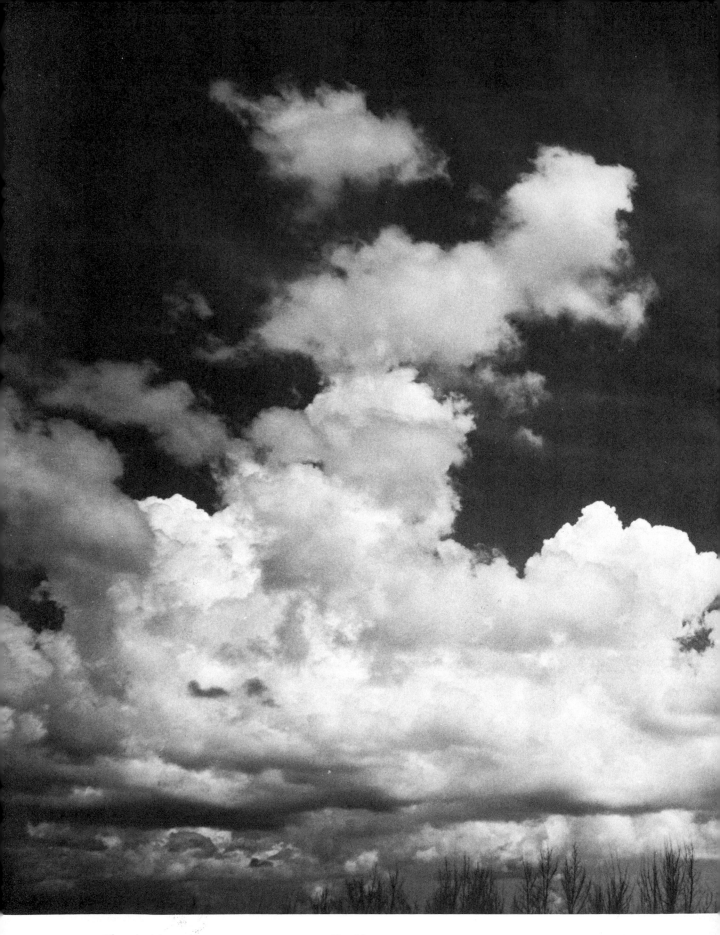

Clouds, view over mangrove swamp, Florida.
(Veriwide; MS pan; #25 red)

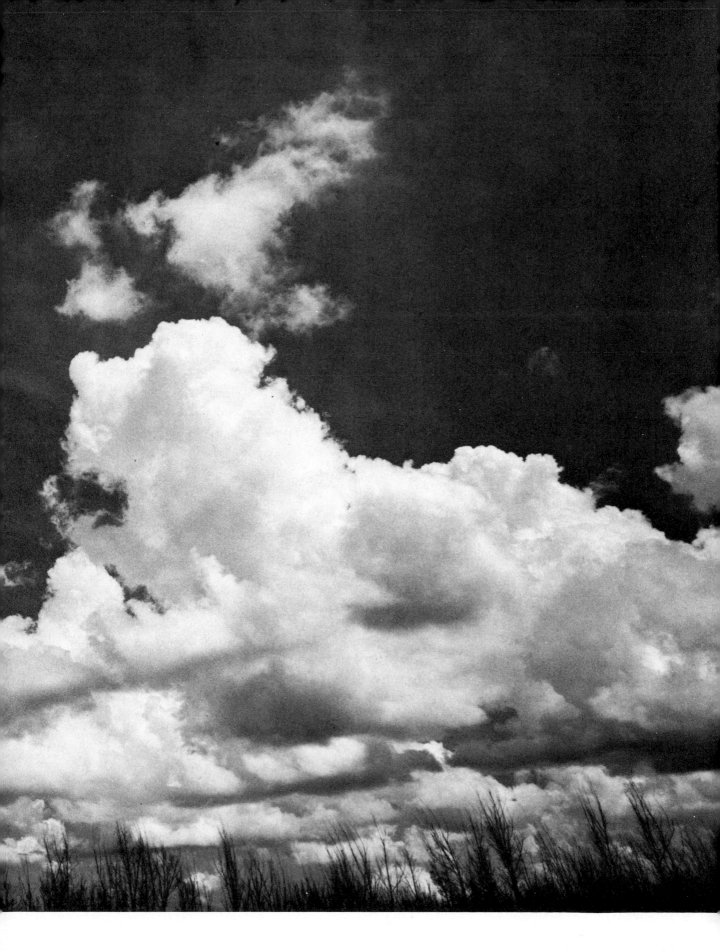

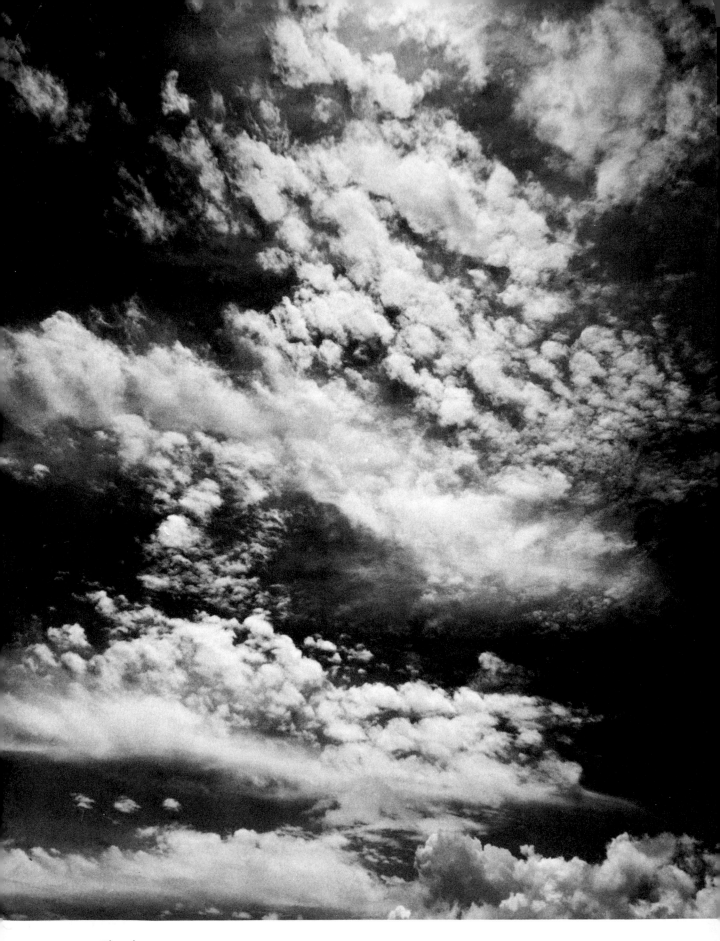

Clouds.

(Veriwide, vertical; MS pan; #25 red)

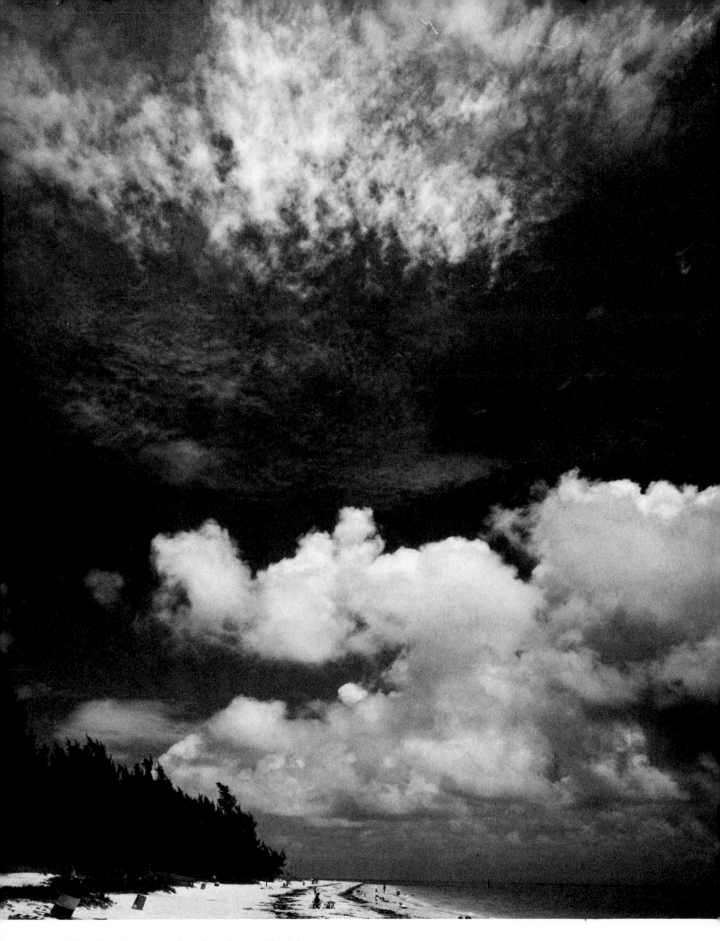

Clouds, view over land and sea, Florida.
(Veriwide, vertical; MS pan; #25 red)

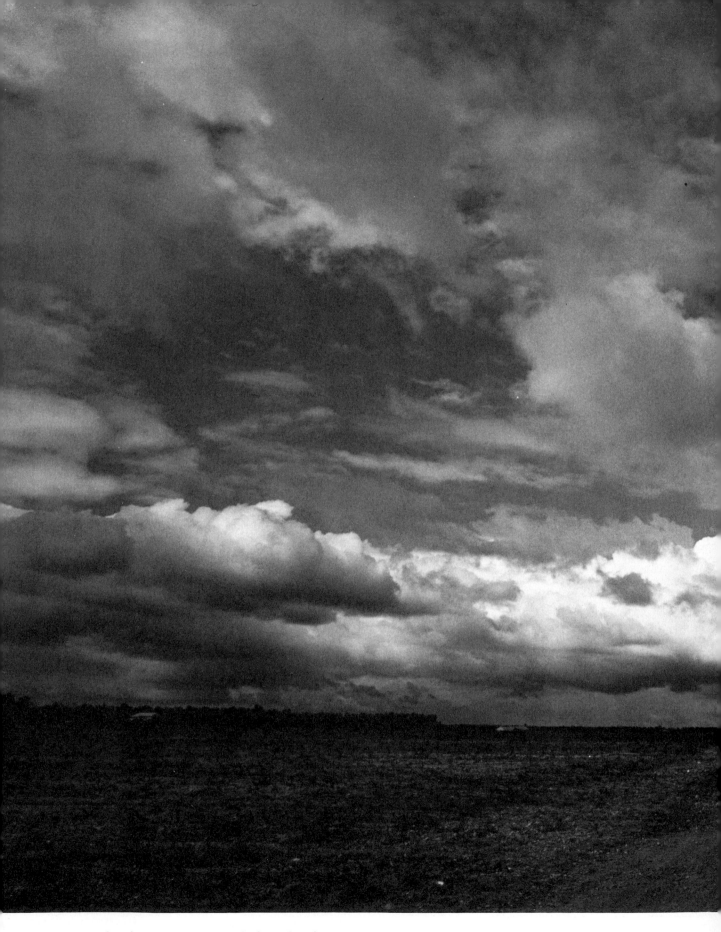

Clouds, view over Everglades, Florida.
(Veriwide; MS pan; #25 red)

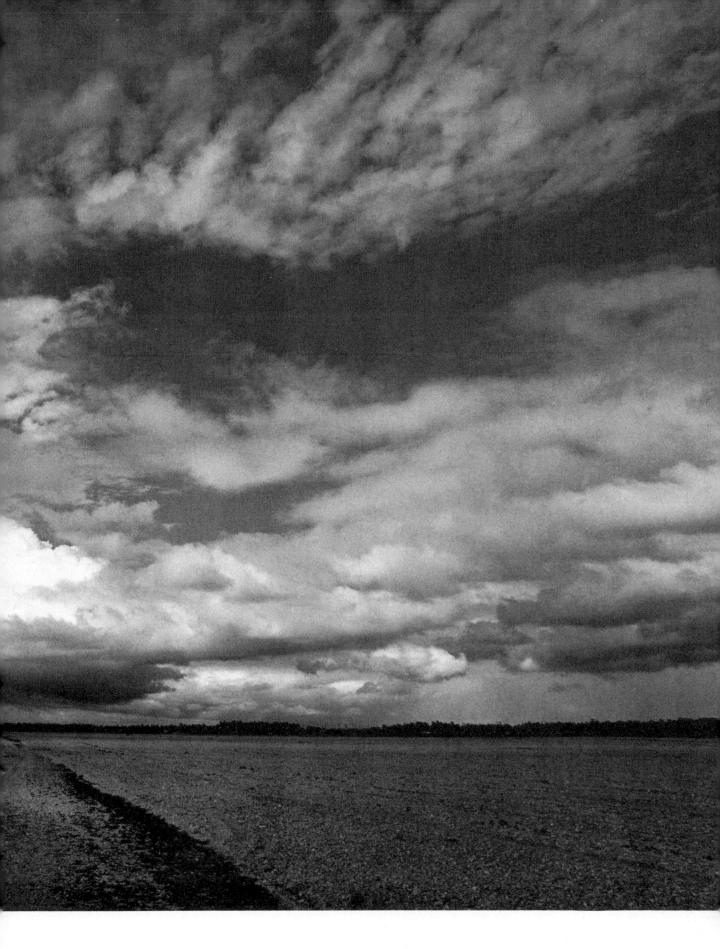

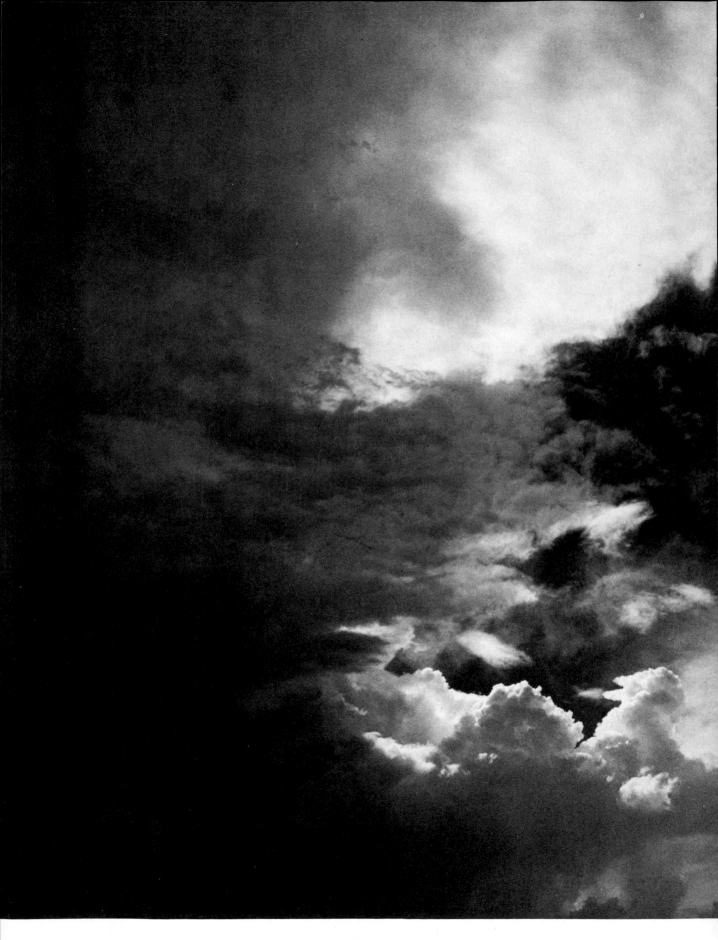

Clouds, view over Atlantic Ocean, Puerto Rico.
14 (Veriwide; MS pan; #25 red)

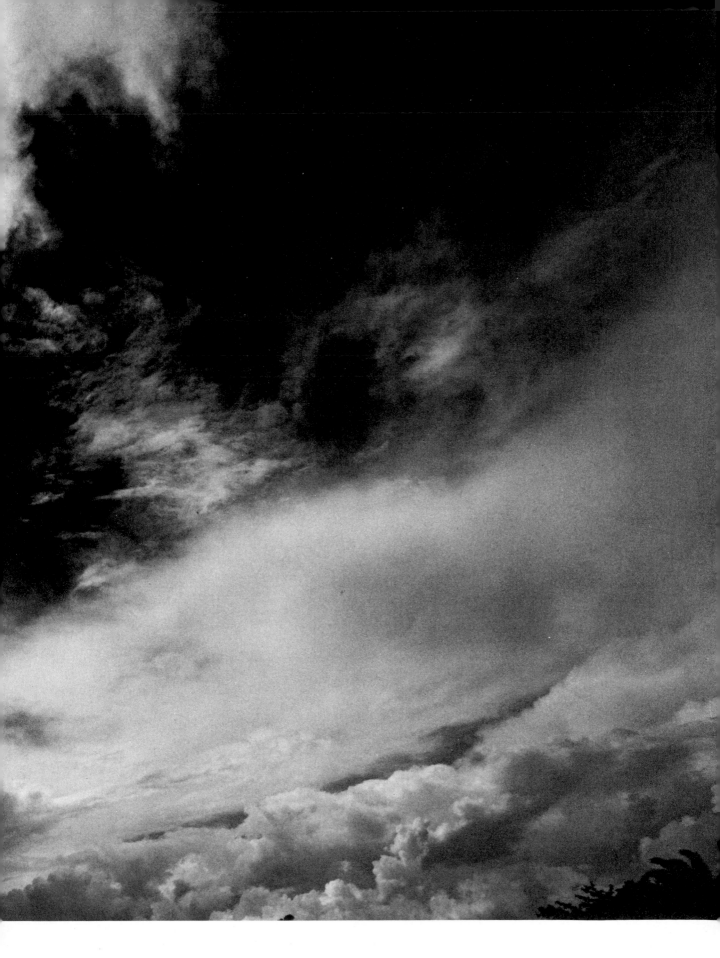

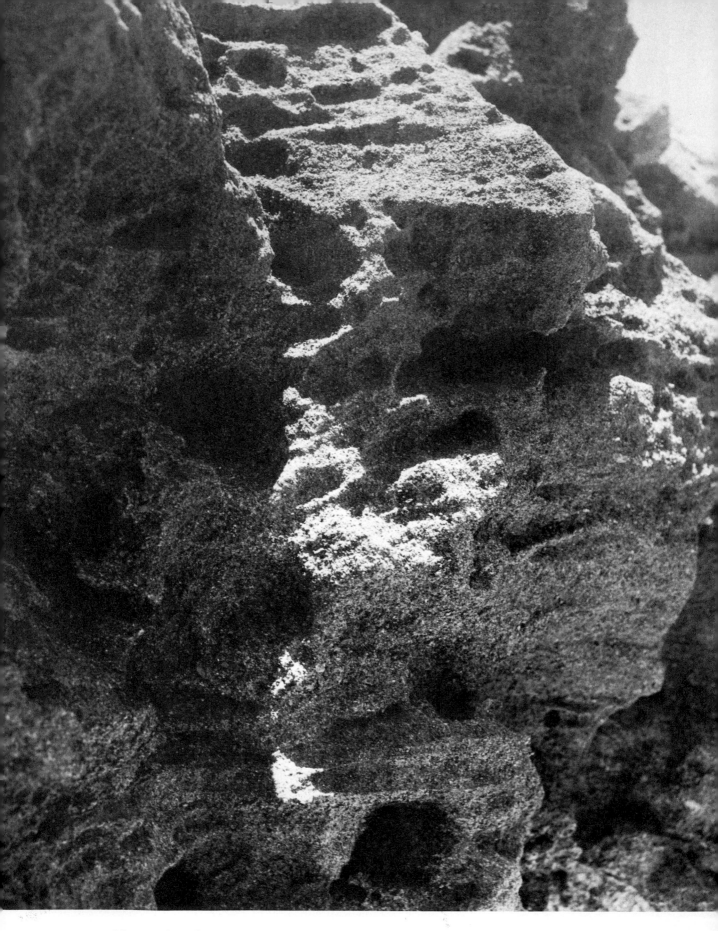

Boulders on beach at Guajataca, Puerto Rico.
16 (Rolleiflex; MS pan; Pola)

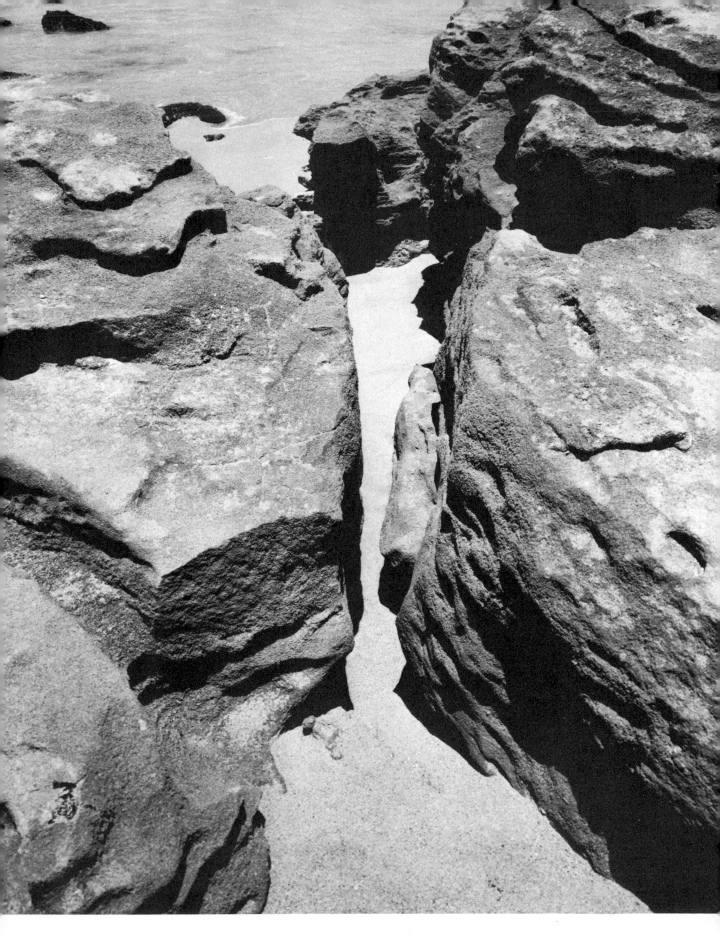

Boulders on beach at Guajataca, Puerto Rico.
(Rolleiflex; MS pan; Pola)

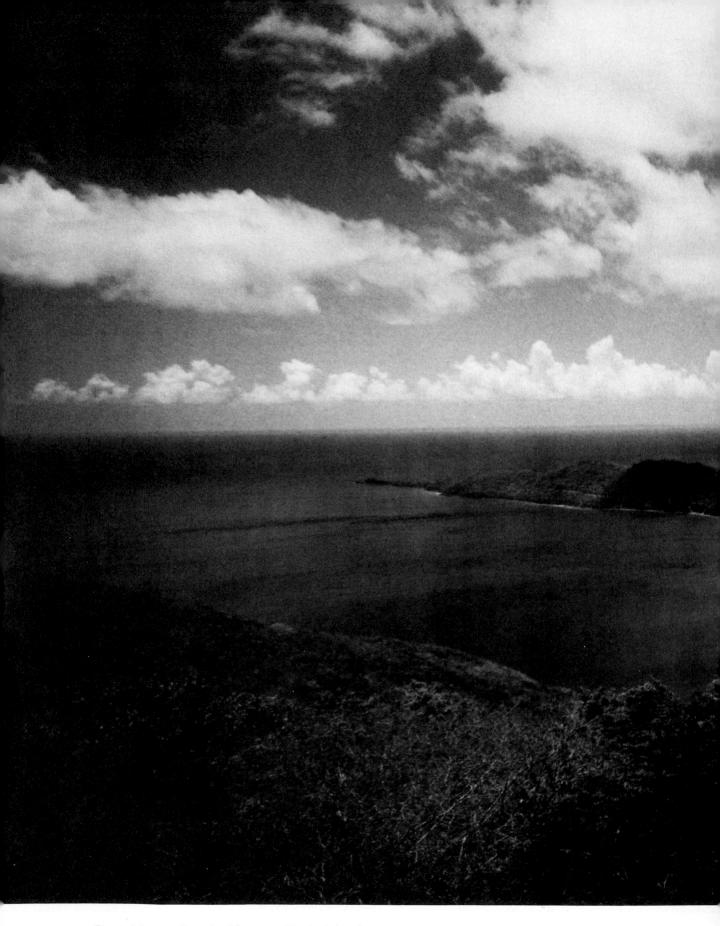

Cove, Magens Bay, St. Thomas, Virgin Islands.
(Veriwide; MS pan; #25 red)

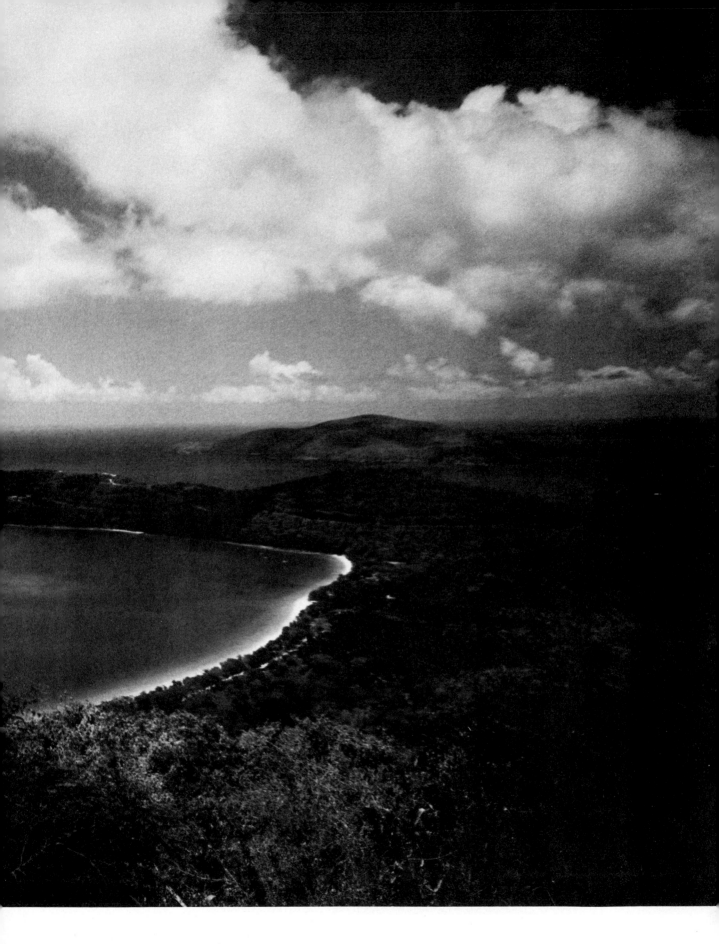

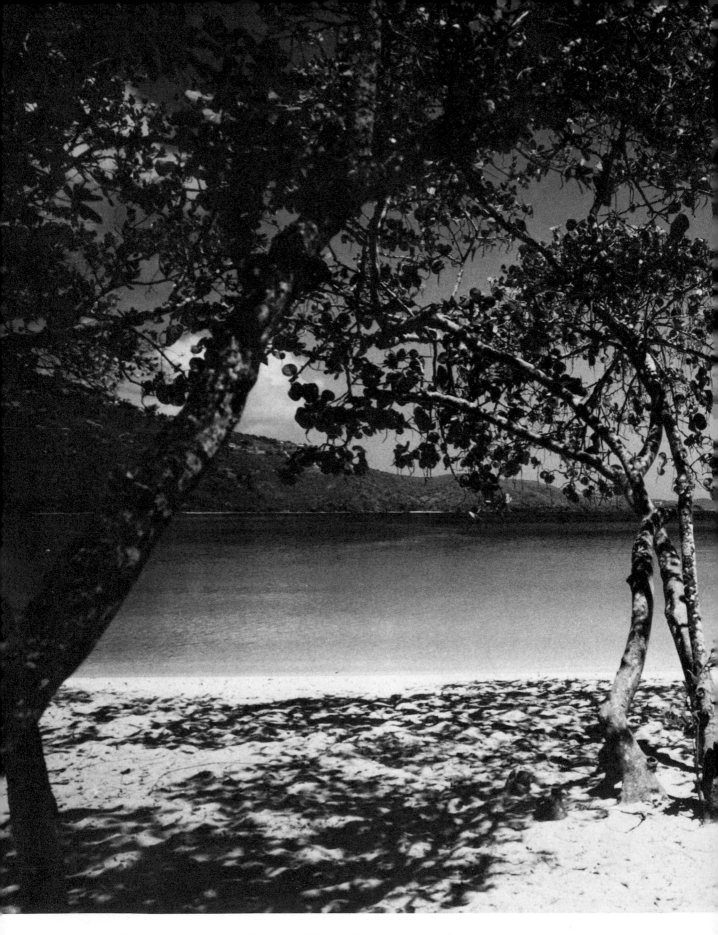

Beach at Magens Bay, St. Thomas, Virgin Islands.
(Veriwide; MS pan; #25 red)

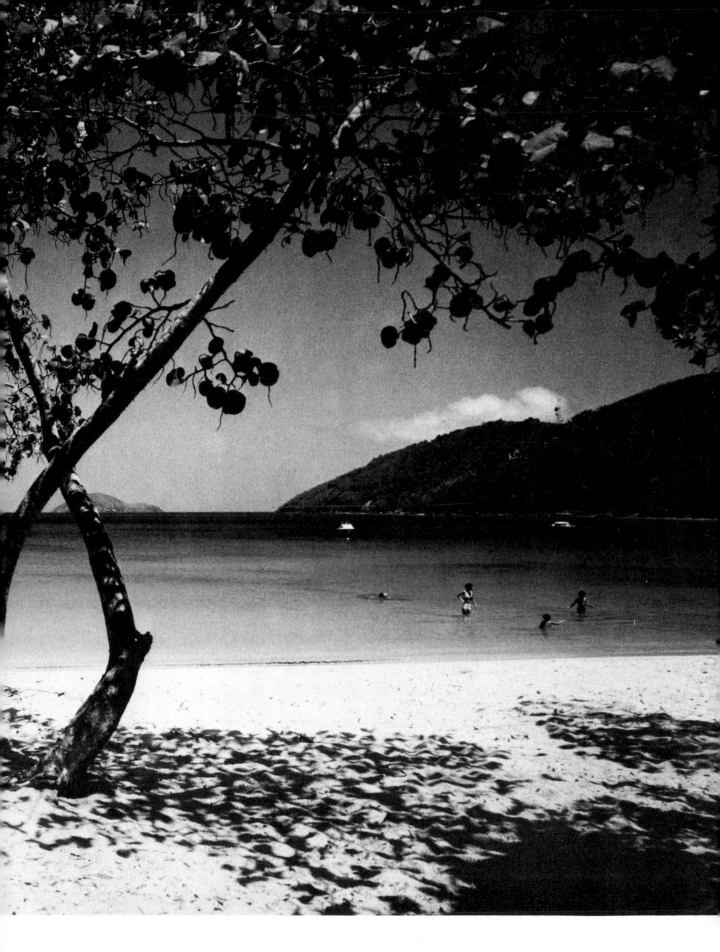

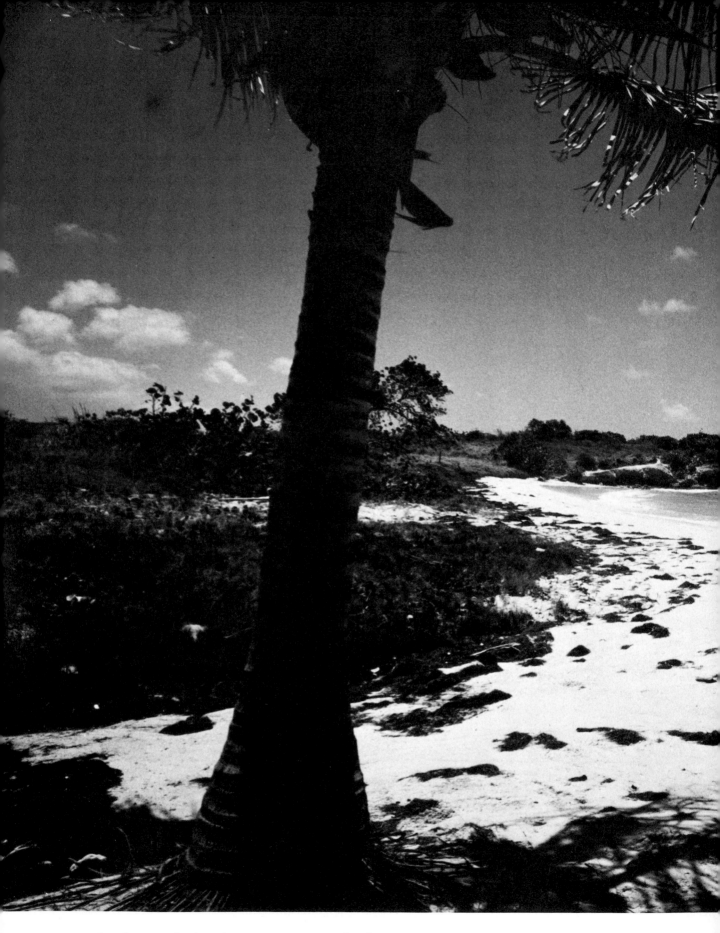

Beach at Frederiksted, St. Croix, Virgin Islands.
(Veriwide; MS pan; #25 red)

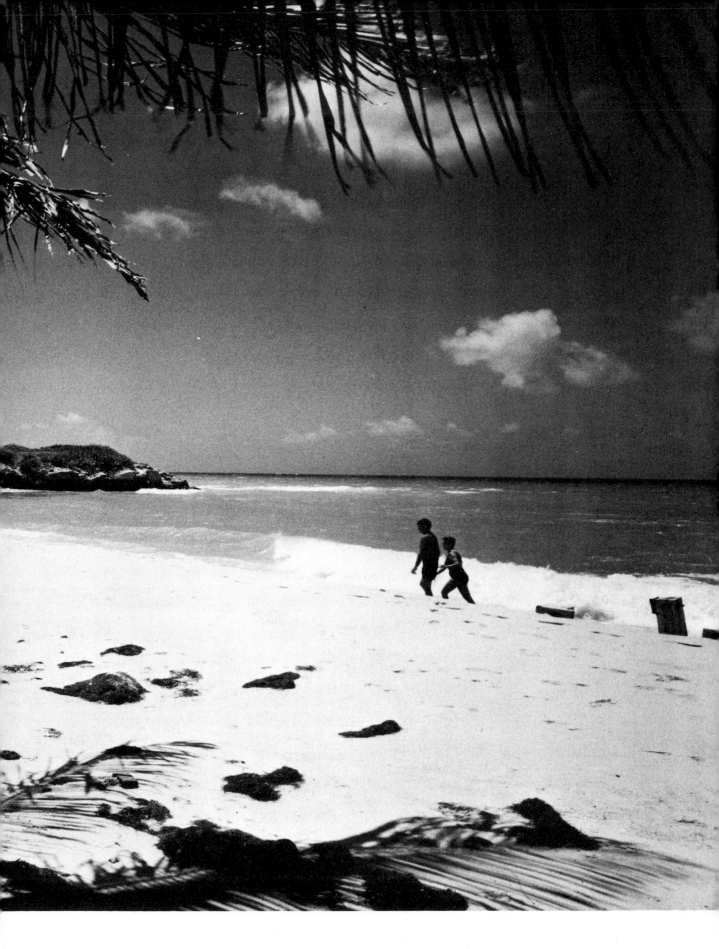

Beach at Frederiksted, St. Croix, Virgin Islands.
24 (Rolleiflex; MS pan; Pola)

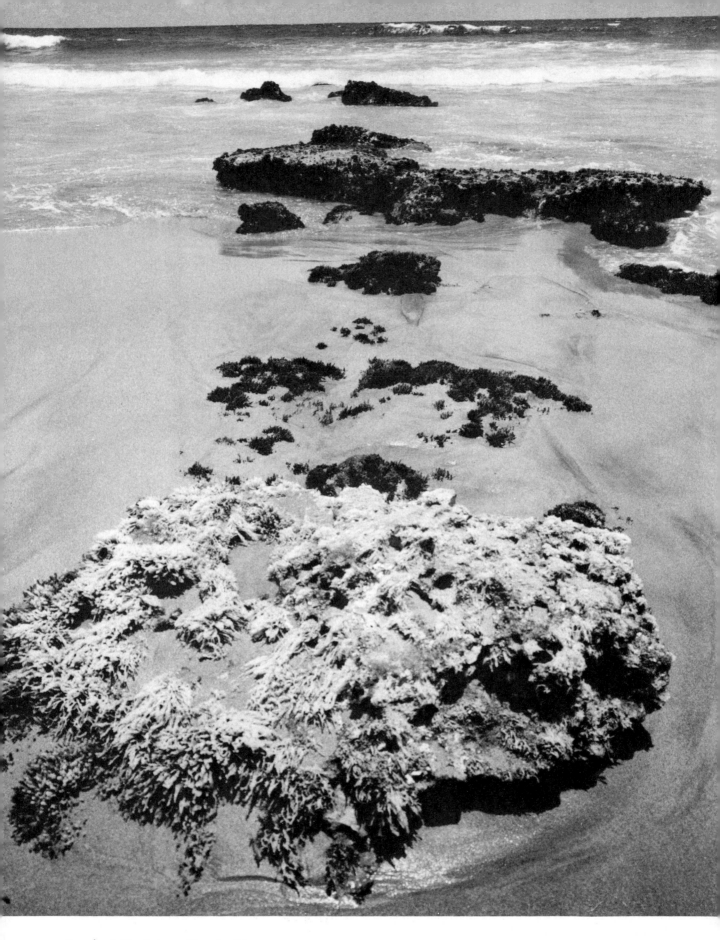

Beach at Guajataca, Puerto Rico.
(Rolleiflex; MS pan; Pola)

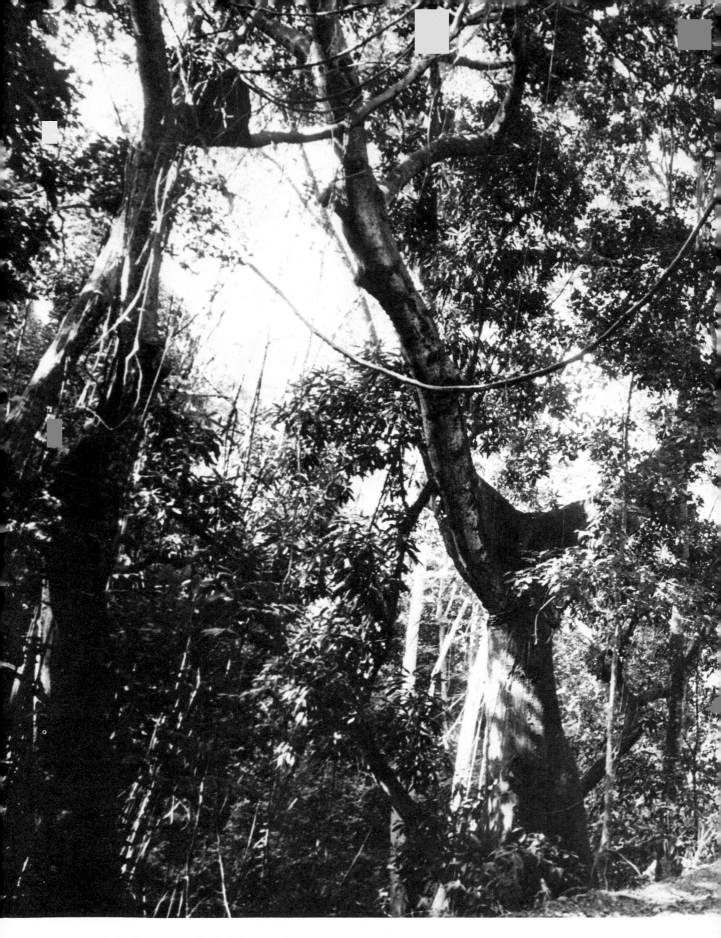

Rain forest, St. Croix, Virgin Islands.
(Veriwide; HS pan)

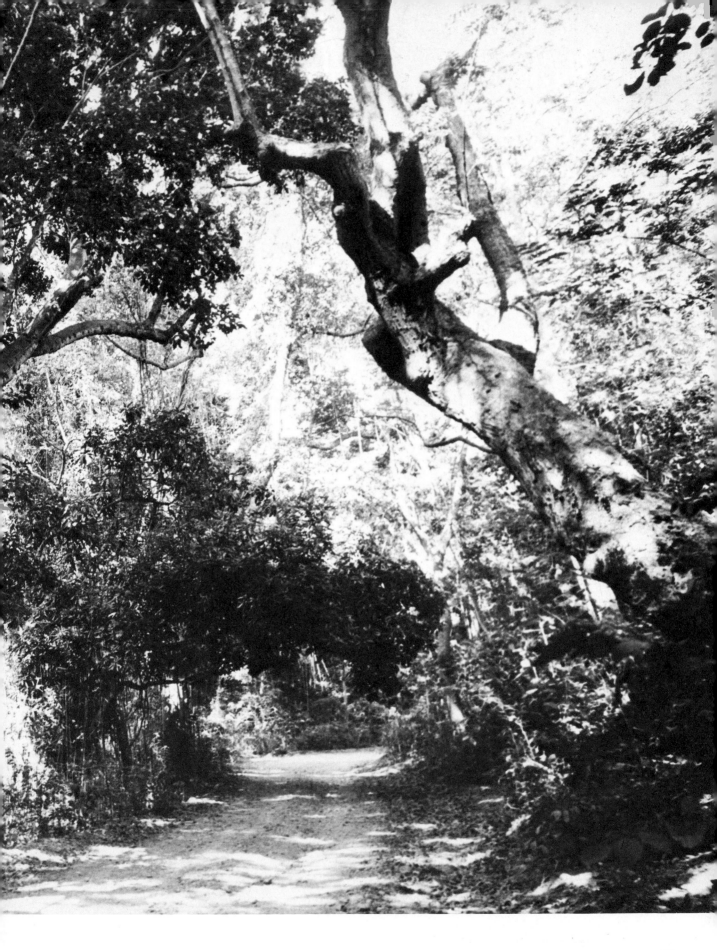

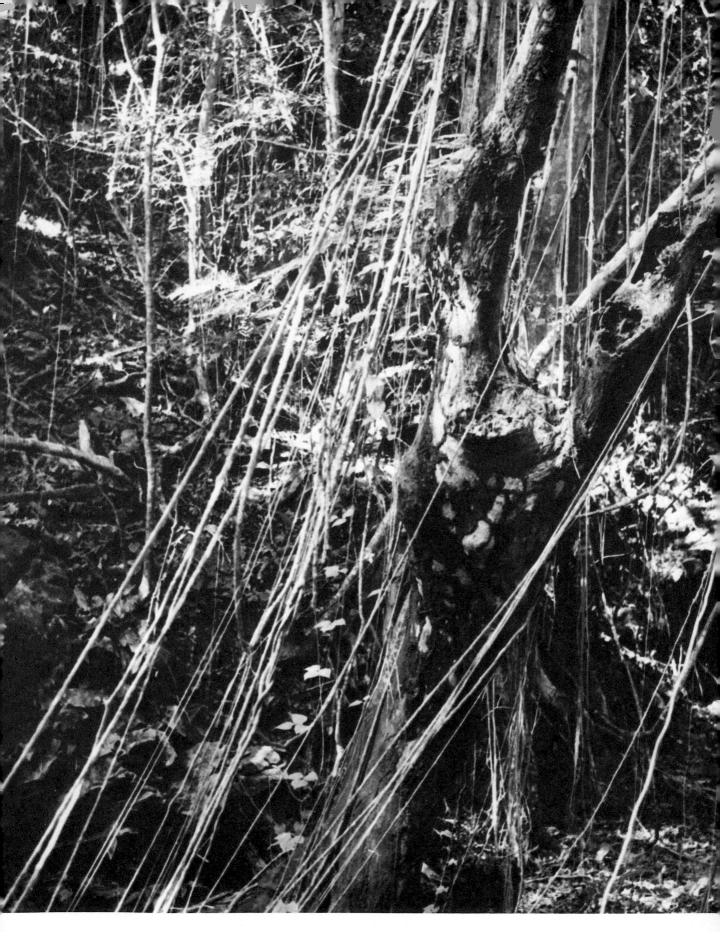

Rain forest, St. Croix, Virgin Islands.

(Veriwide, vertical; HS pan)

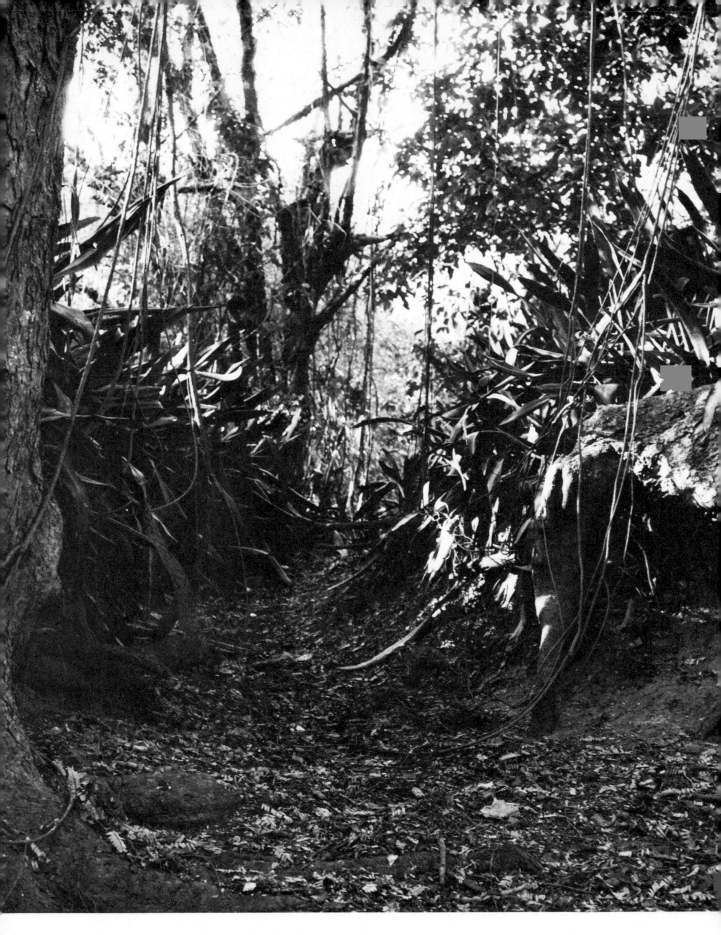

Rain forest, St. Croix, Virgin Islands.
(Veriwide, vertical; HS pan)

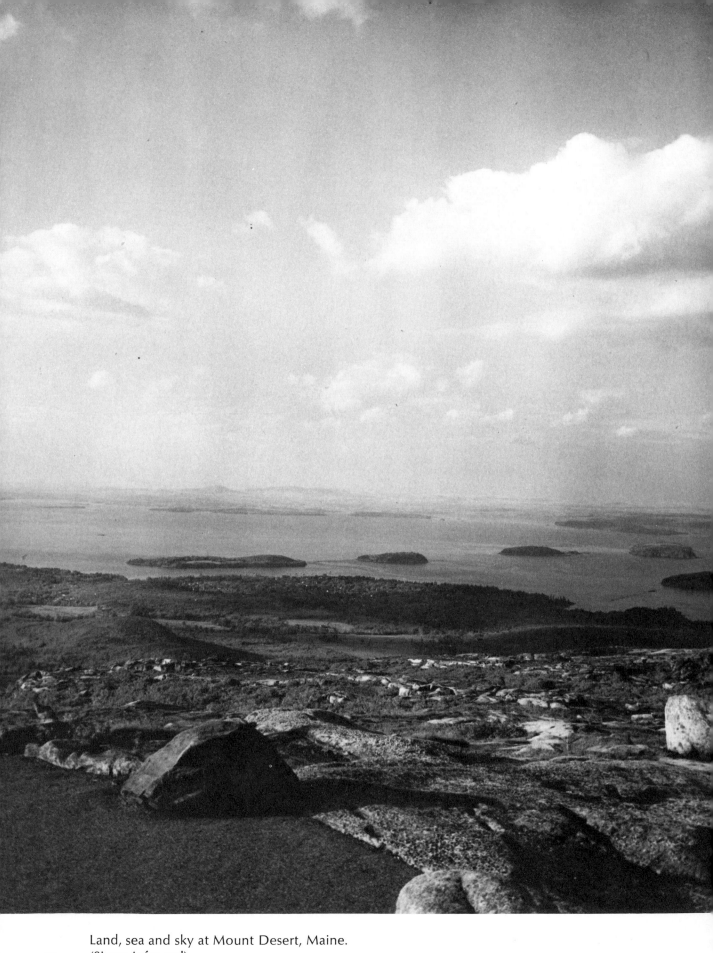

Land, sea and sky at Mount Desert, Maine.
(Sinar; infra red)

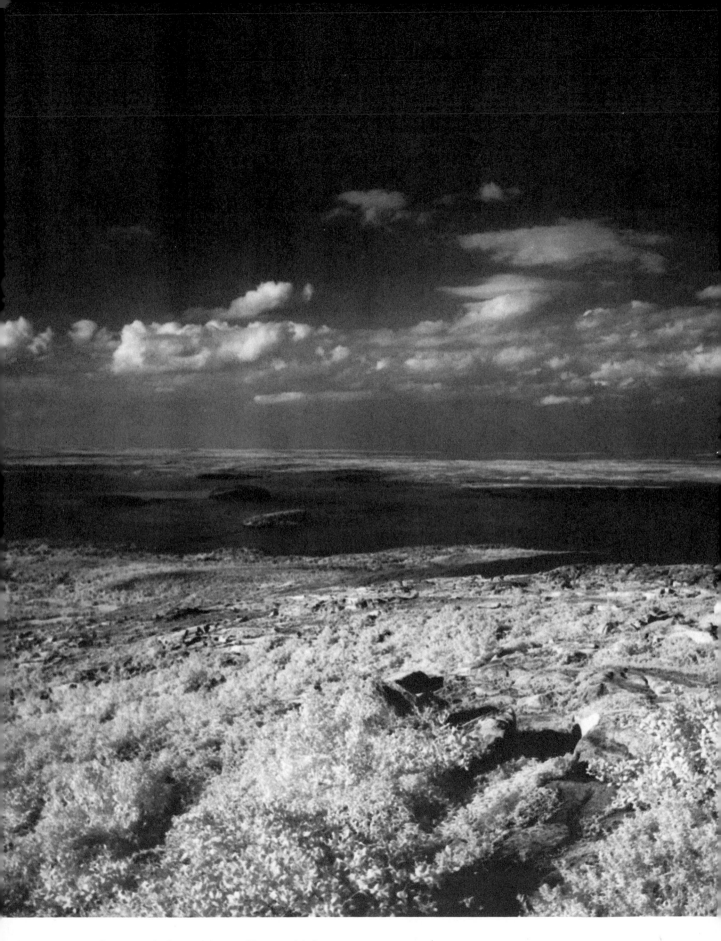

Land, sea and sky at Mount Desert, Maine.
(Sinar; infra red; #29 red)

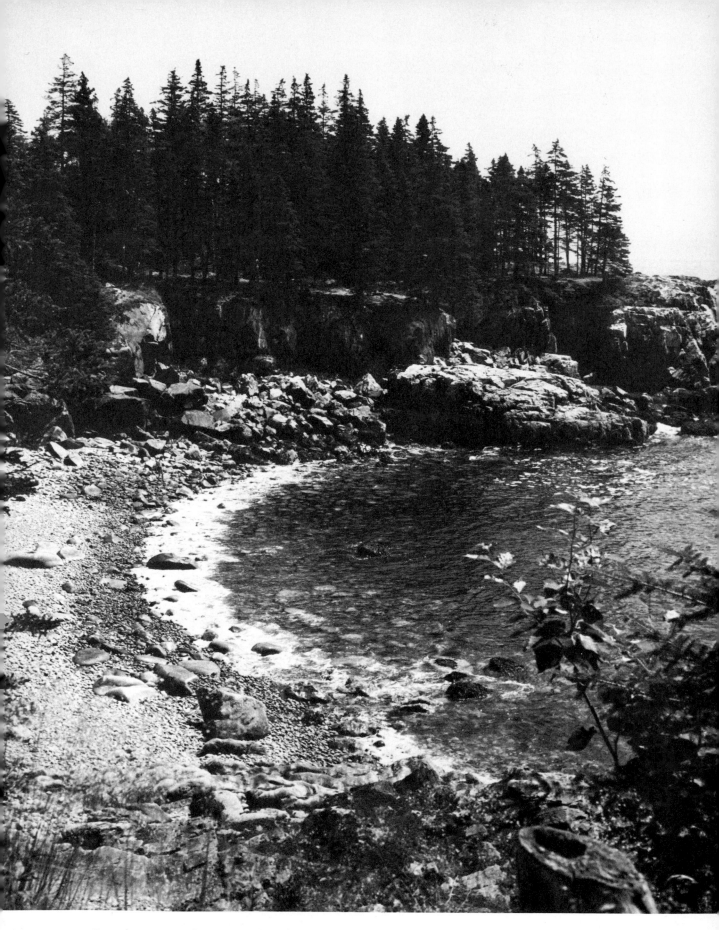

Coastline at Acadia National Park, Maine.
(Rolleiflex; MS pan; Pola)

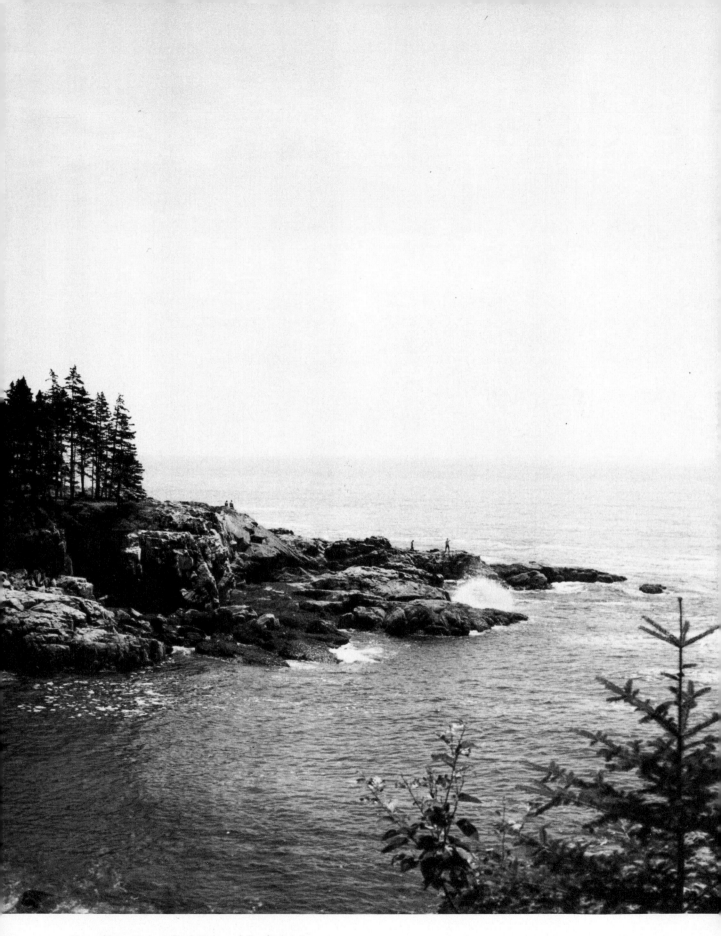

Coastline at Acadia National Park, Maine.
(Rolleiflex; MS pan; Pola)

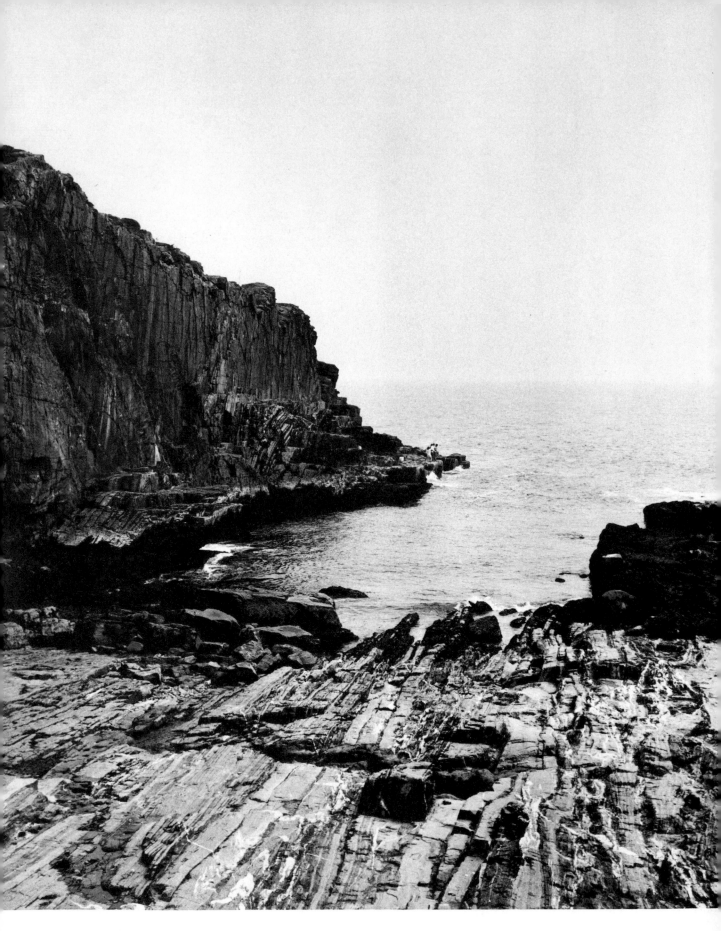

Bald Head Cliffs, Ogunquit, Maine.
(Rolleiflex; MS pan; Pola)

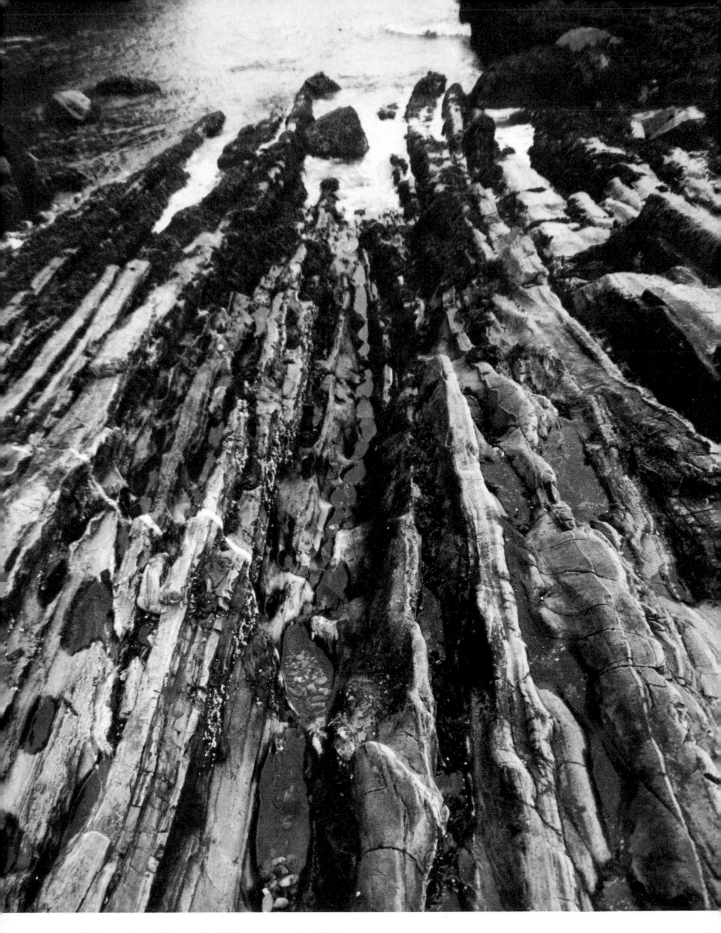

Tidal pools, Bald Head Cliffs, Ogunquit, Maine.
(Rolleiflex; MS pan; Pola)

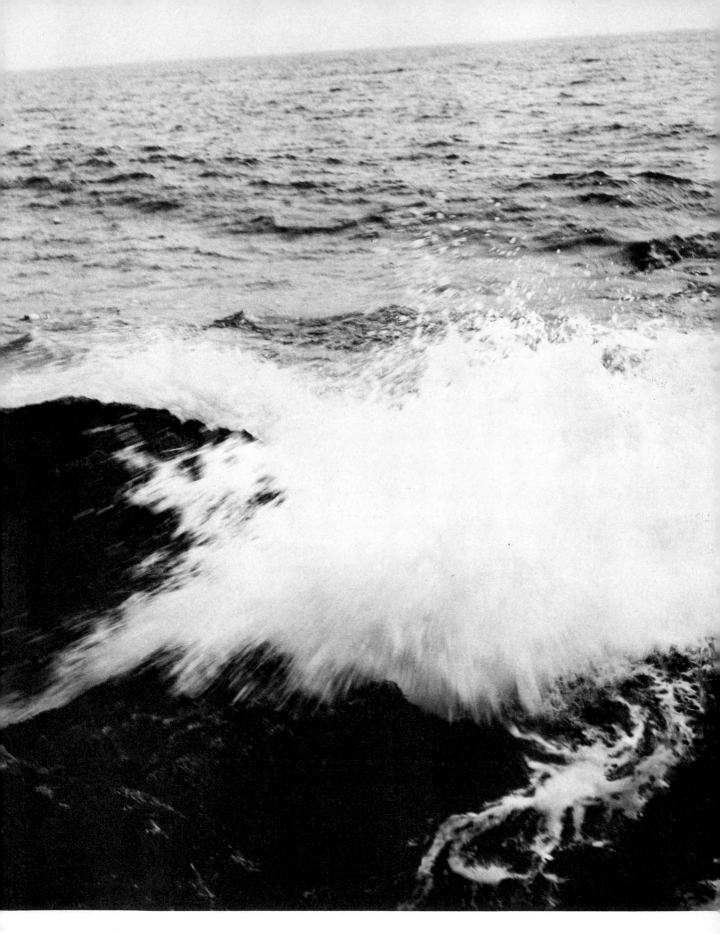

Surf on stone, Acadia National Park, Maine.

(Rolleiflex; MS pan; Pola)

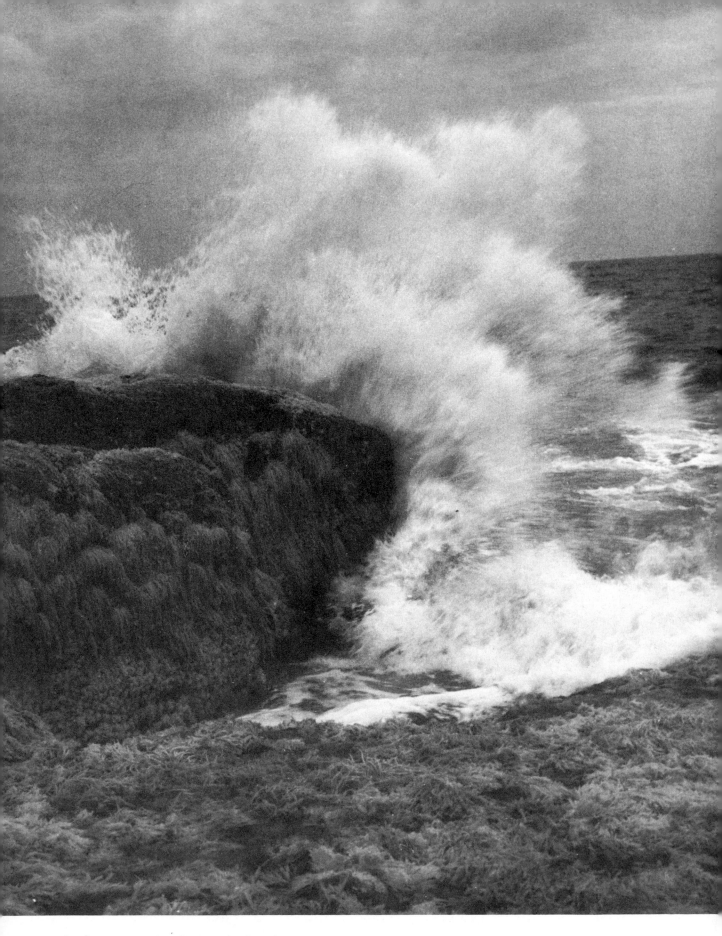

Surf on stone, Acadia National Park, Maine.
(Rolleiflex; MS pan; Pola)

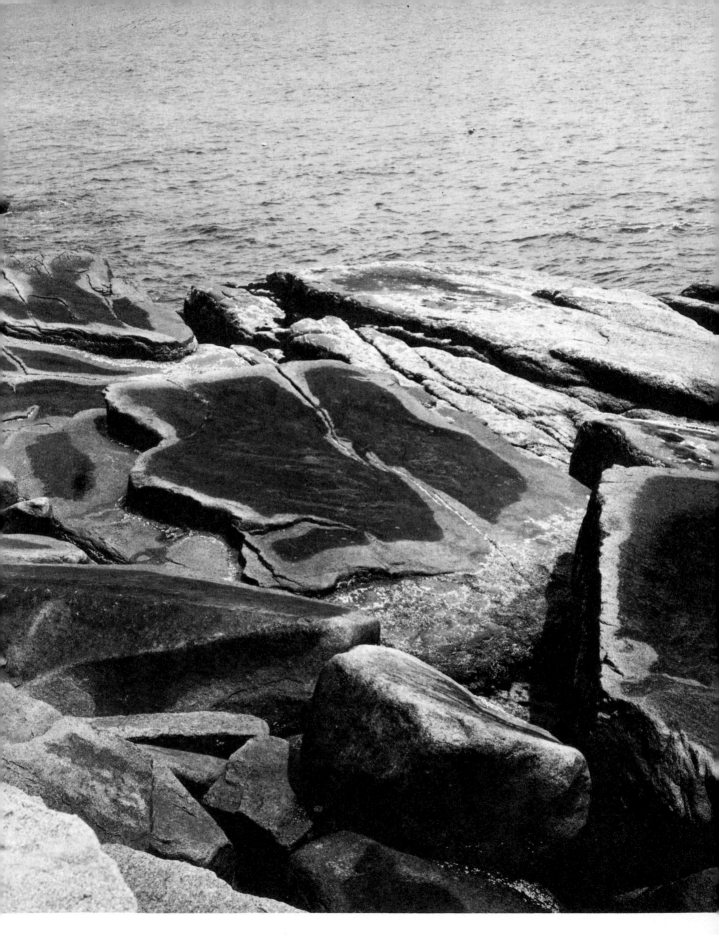

Coastline, Acadia National Park, Maine.
(Rolleiflex; MS pan; Pola)

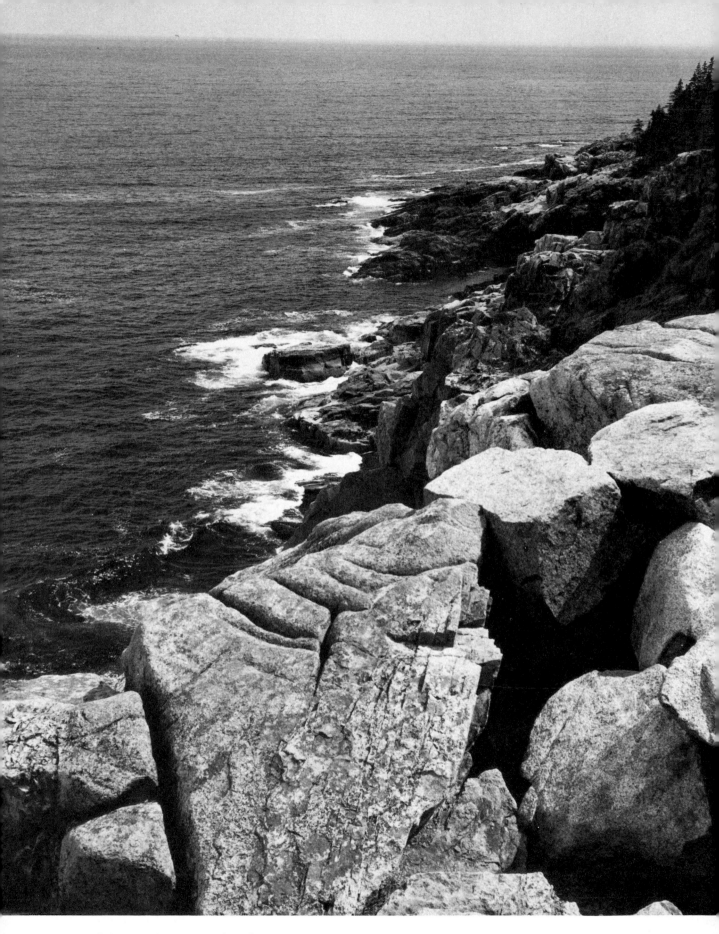

Coastline, Acadia National Park, Maine.
(Rolleiflex; MS pan; Pola)

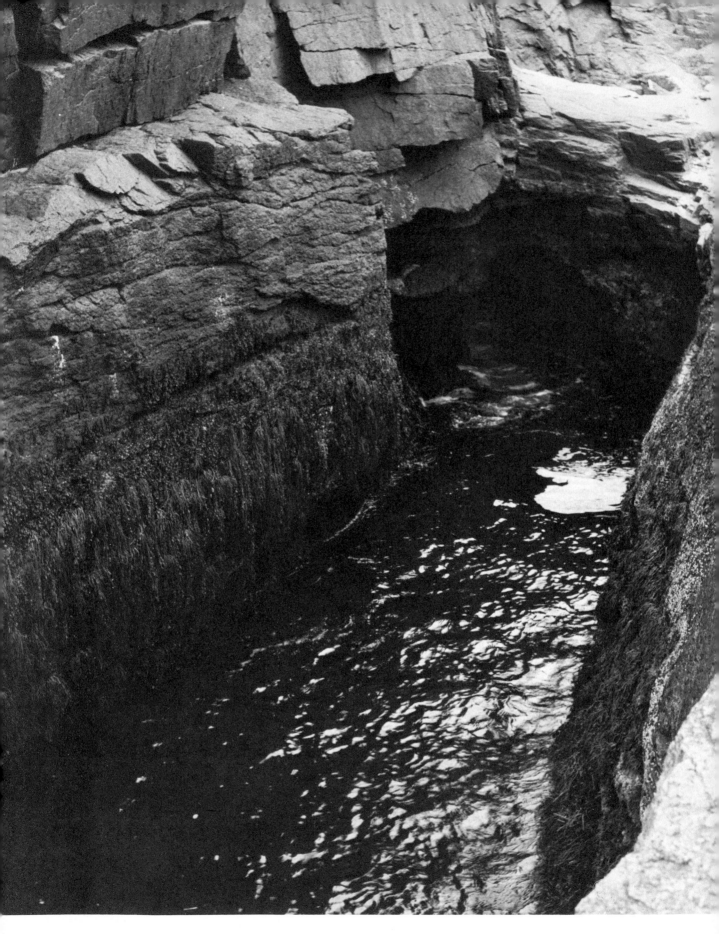

Coastline, Thunder Hole, Acadia National Park, Maine.
(Rolleiflex; MS pan)

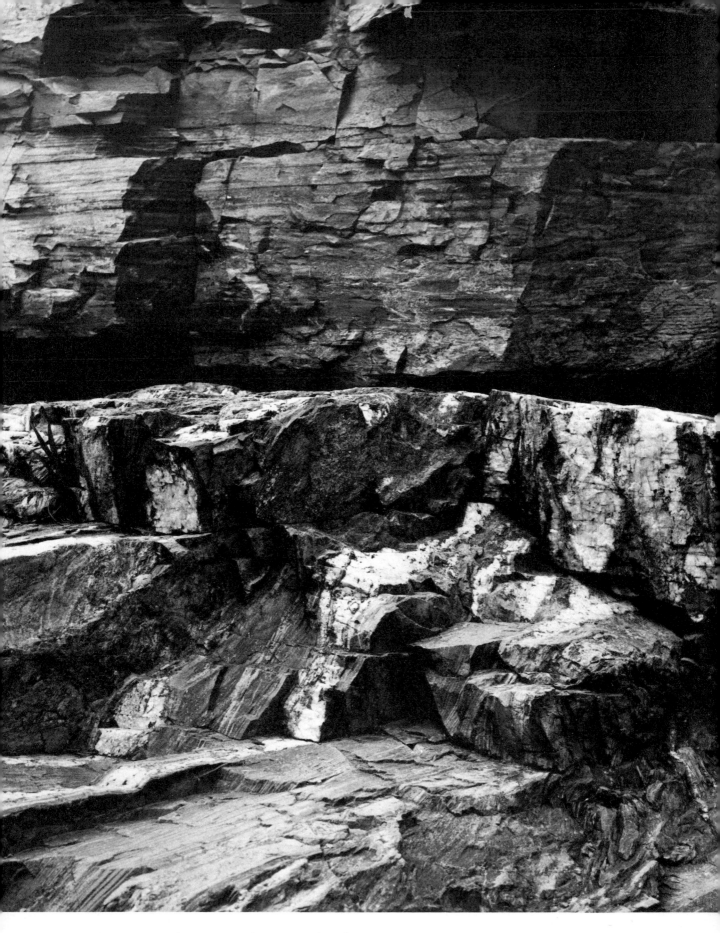

Coastline, layers of stone, Acadia National Park, Maine.
(Rolleiflex; MS pan)

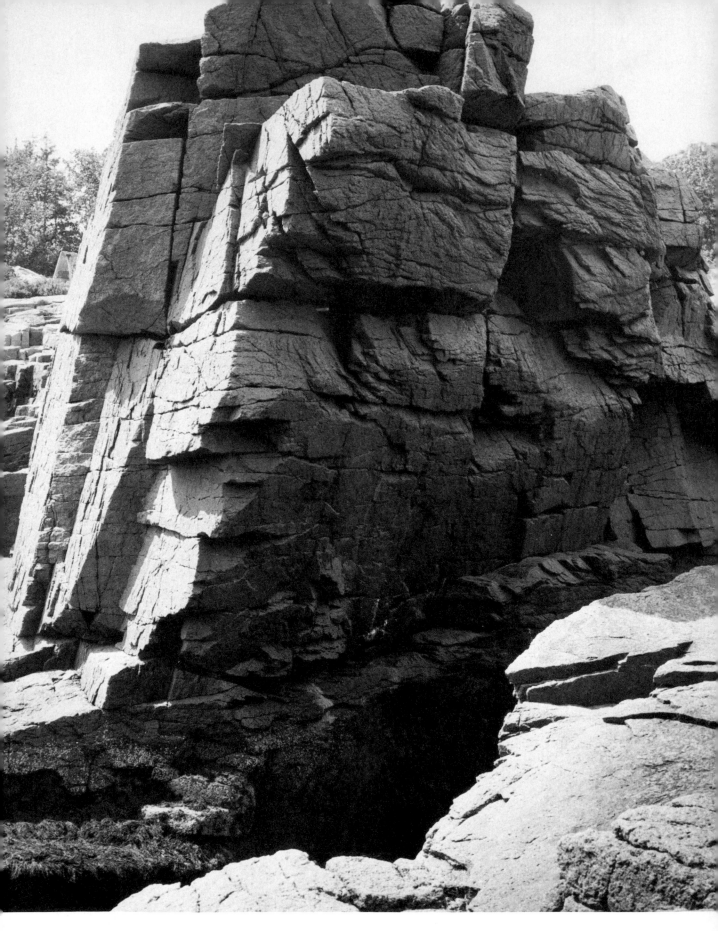

Coastline, layers of stone, Acadia National Park, Maine.
(Rolleiflex; MS pan)

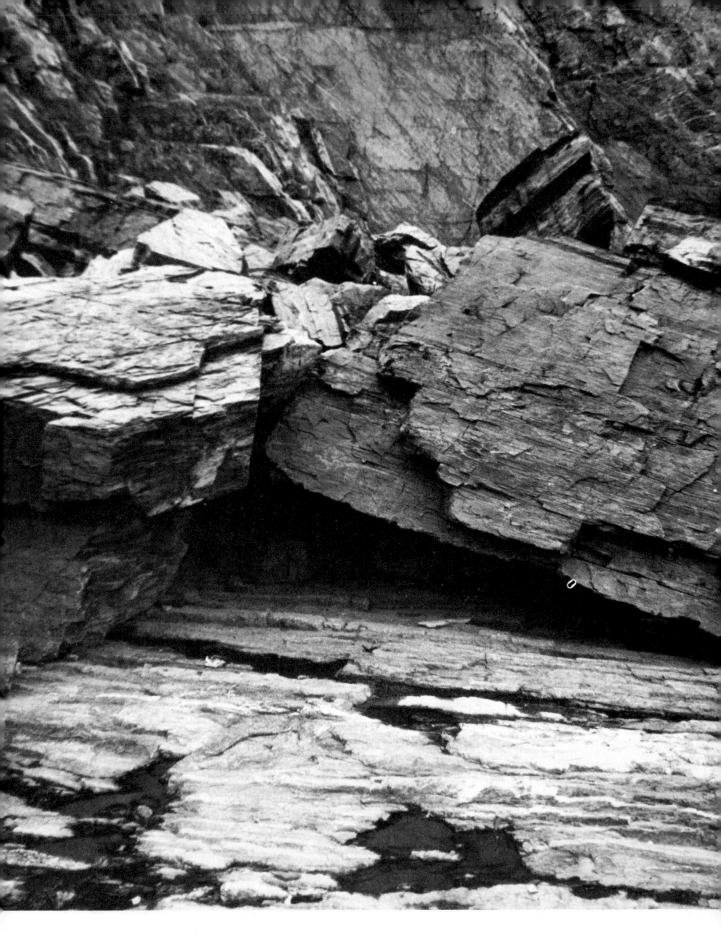

Coastline, layers of stone, Acadia National Park, Maine.
(Rolleiflex; MS pan)

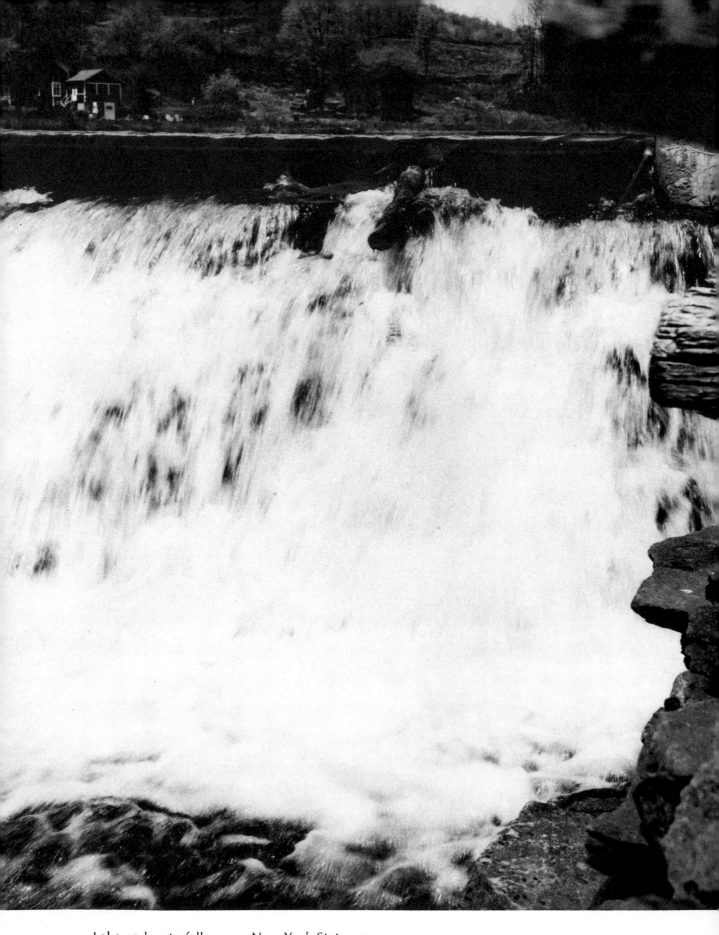

Lake and waterfall, upper New York State.
(Rolleiflex; MS pan; Pola)

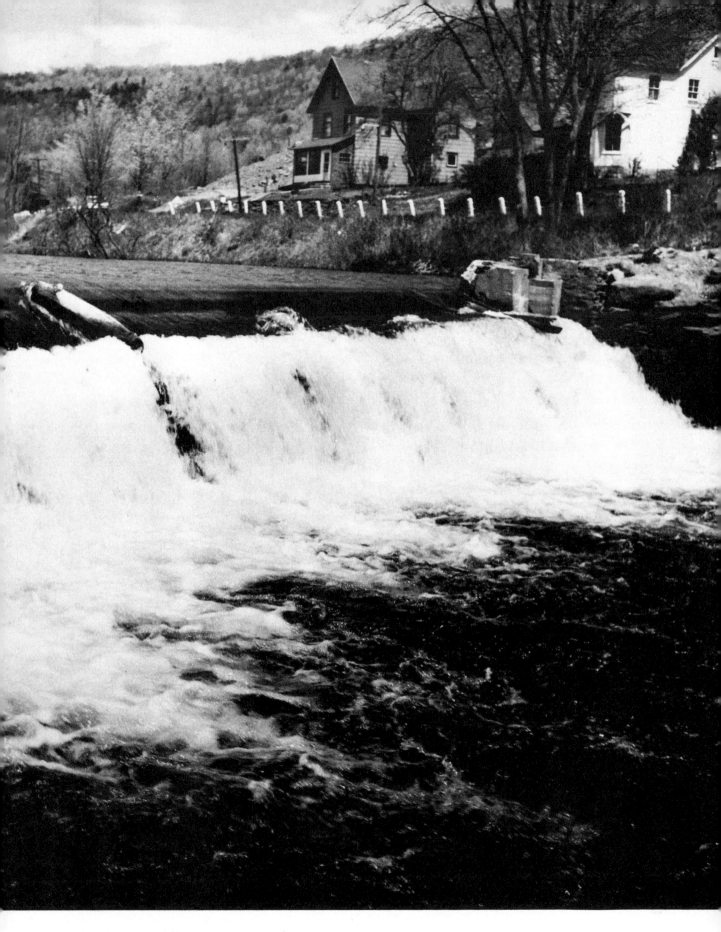

Lake and waterfall, upper New York State.
(Rolleiflex; MS pan; Pola)

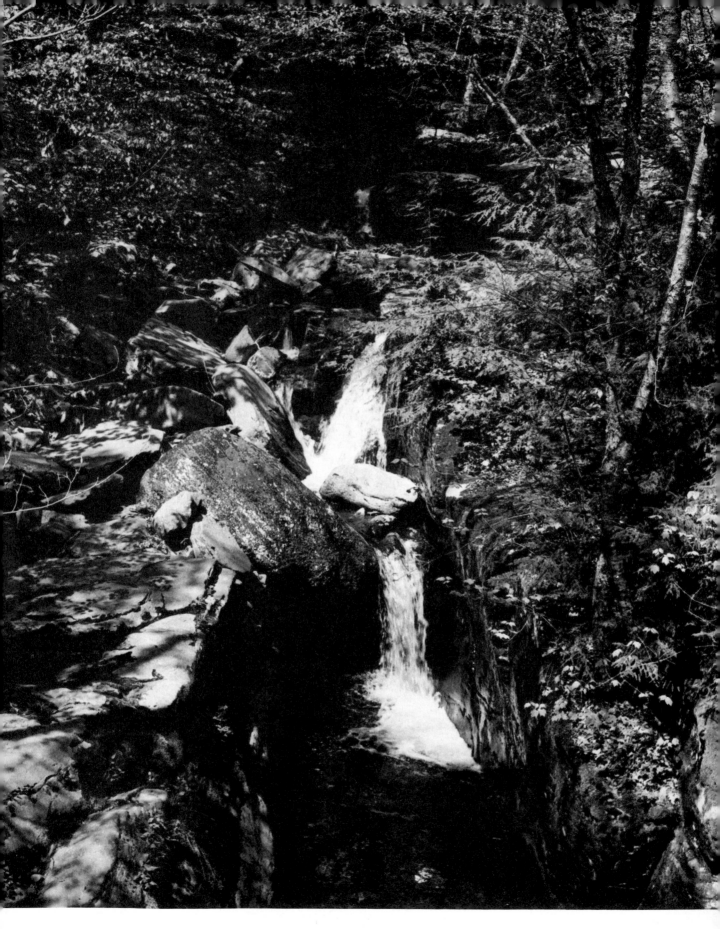

Waterfall, mountains of Pennsylvania.
(Rolleiflex; MS pan)

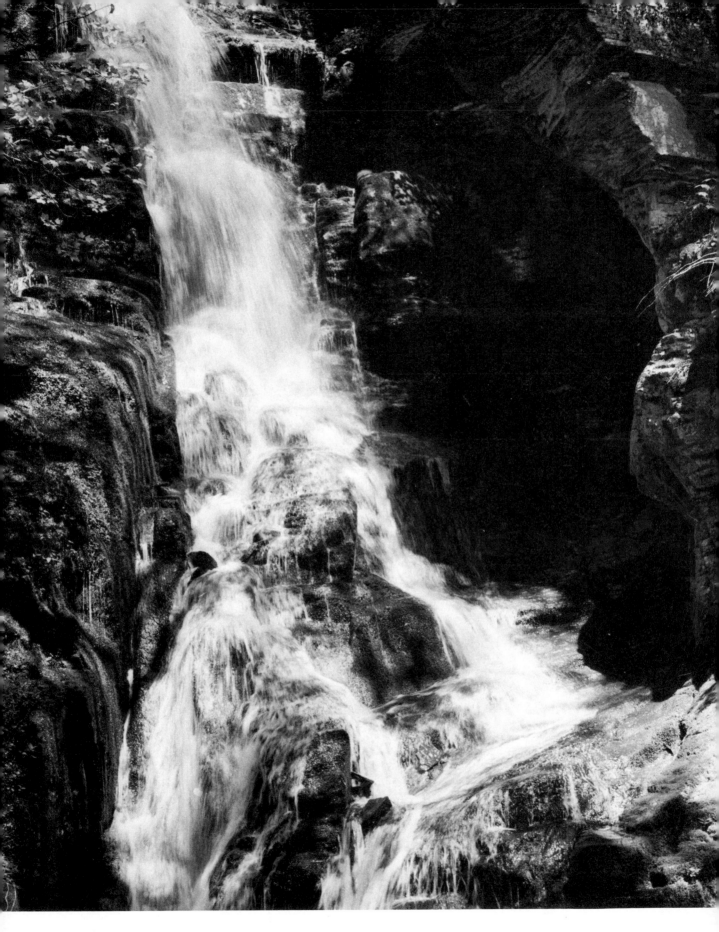

Buttermilk Falls, New York.
(Sinar; MS pan)

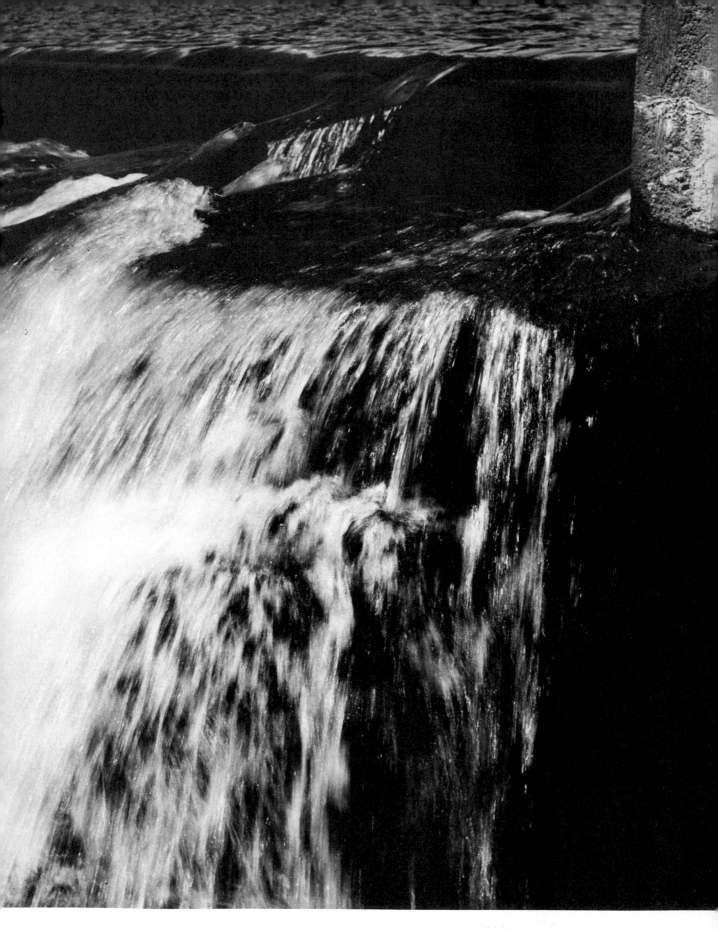

Waterfall, upper New York State.
(Rolleiflex; MS pan; Pola)

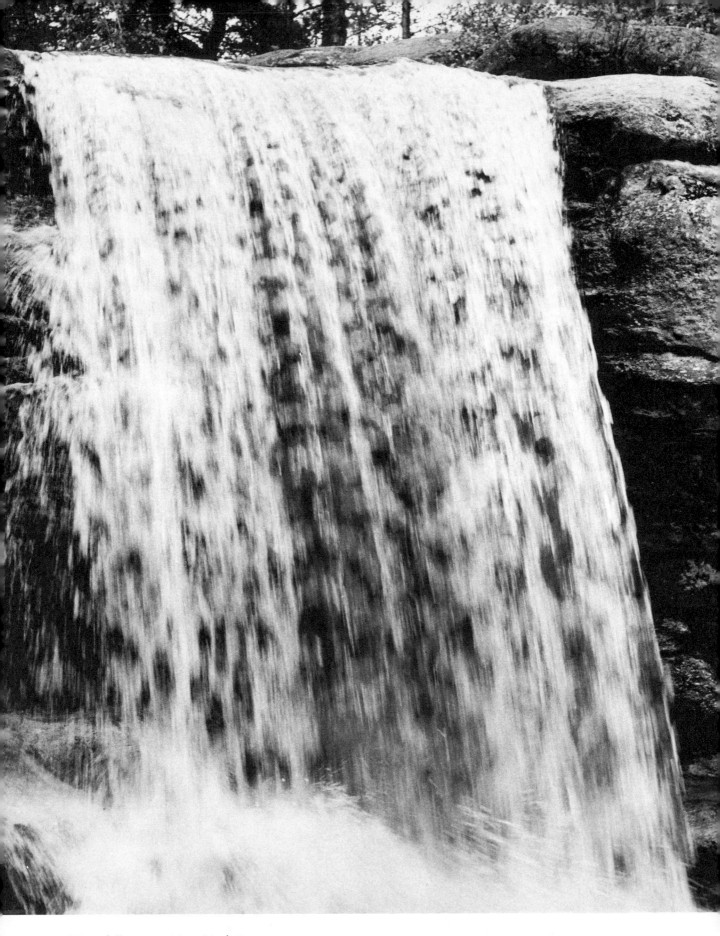

Waterfall, upper New York State.
(Rolleiflex; MS pan; Pola)

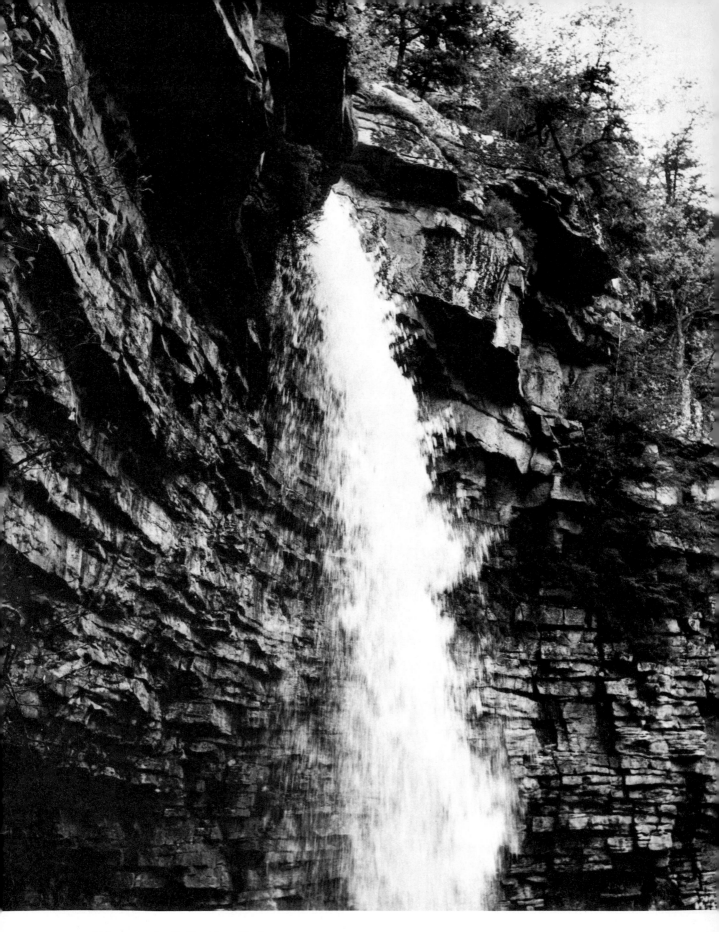

Minnewaska Falls, New York.
(Rolleiflex; MS pan; Pola)

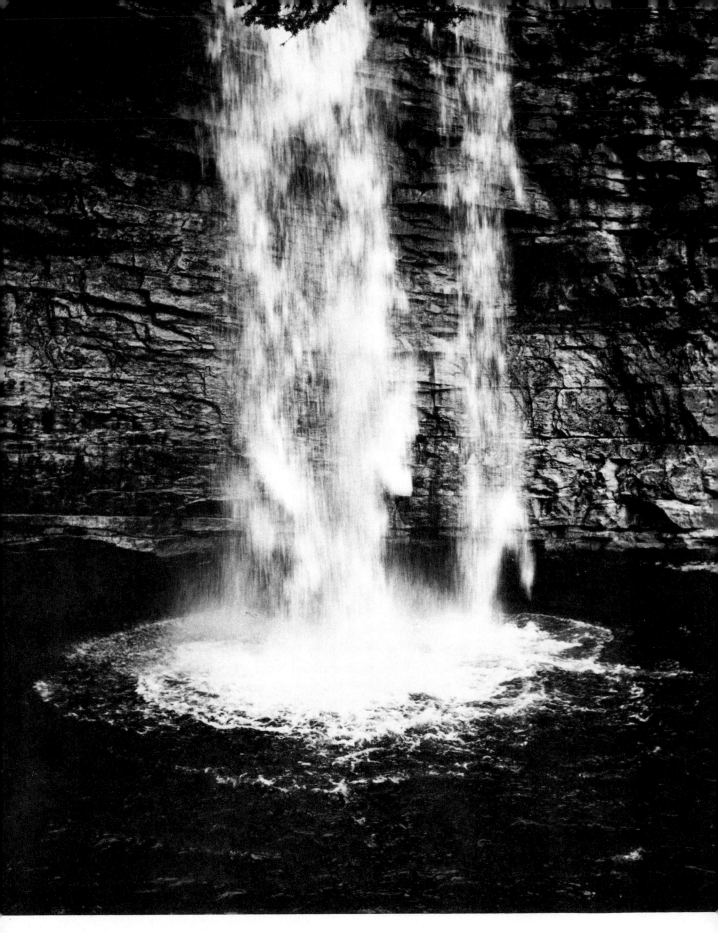

Minnewaska Falls, New York.
(Rolleiflex; MS pan; Pola)

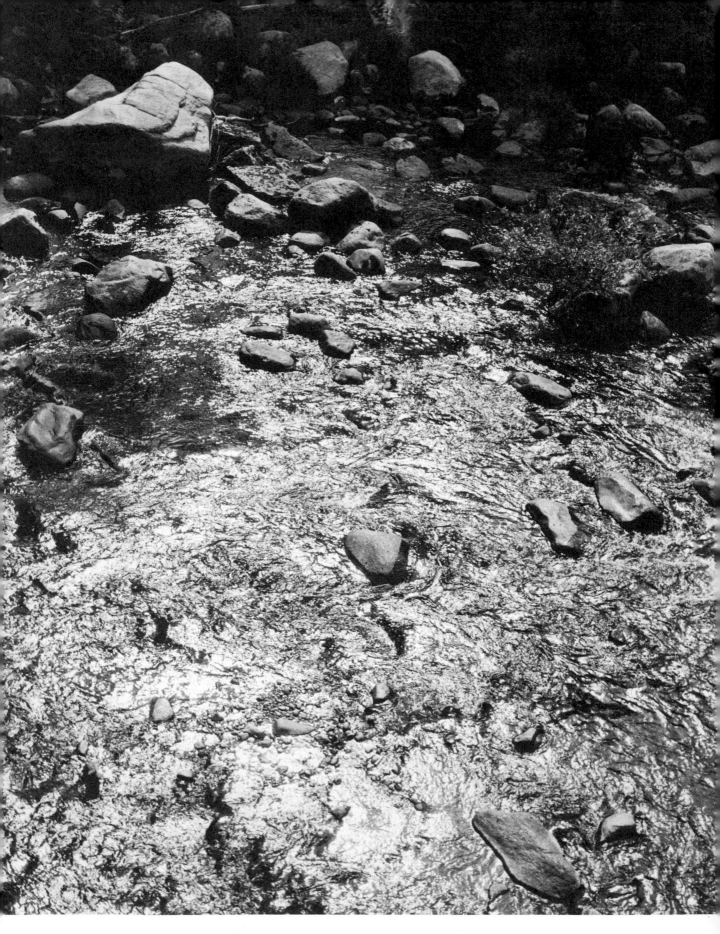

Stream, upper New York State.
(Rolleiflex; MS pan; Pola)

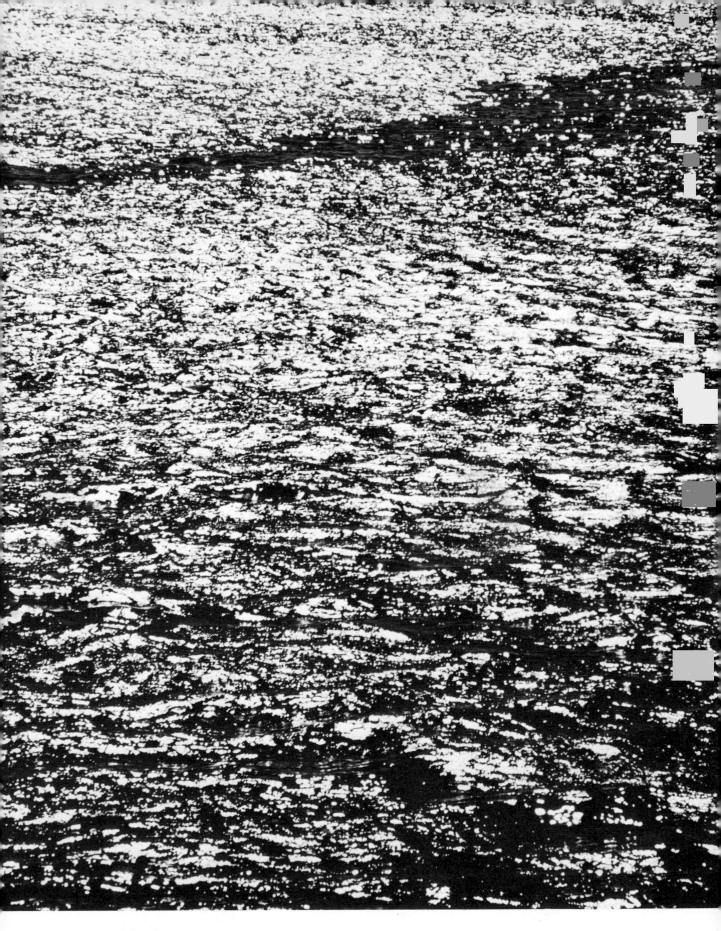

Ocean, Atlantic.
(High contrast derivation from a 2¼"-square transparency)

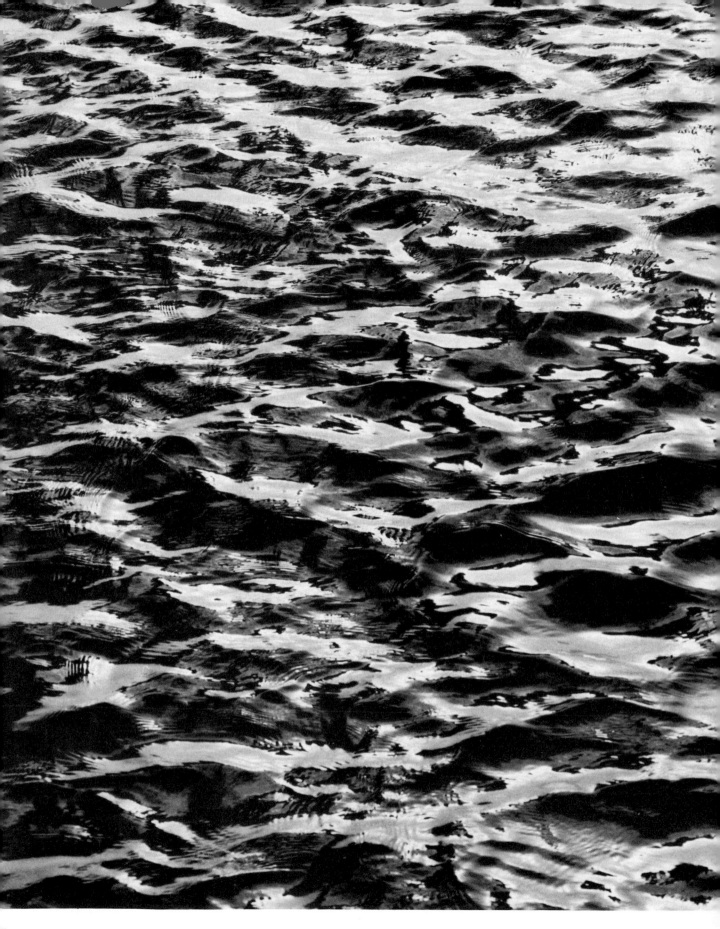

Ocean, wind on sea, Atlantic.
(Rolleiflex; MS pan)

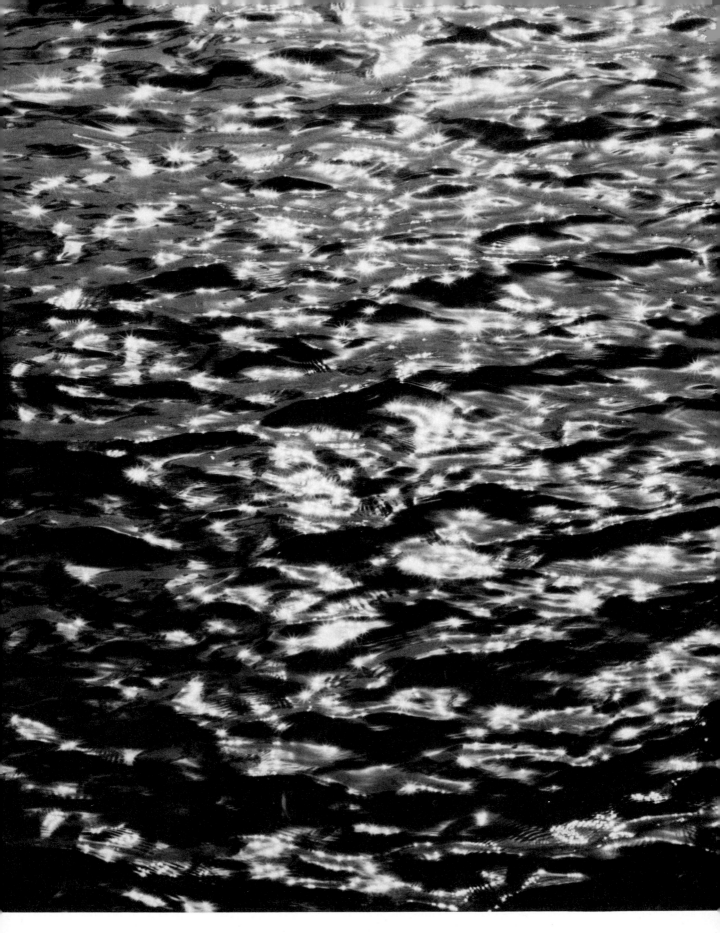

Ocean, sunlight on sea, Atlantic.
(Rolleiflex; MS pan)

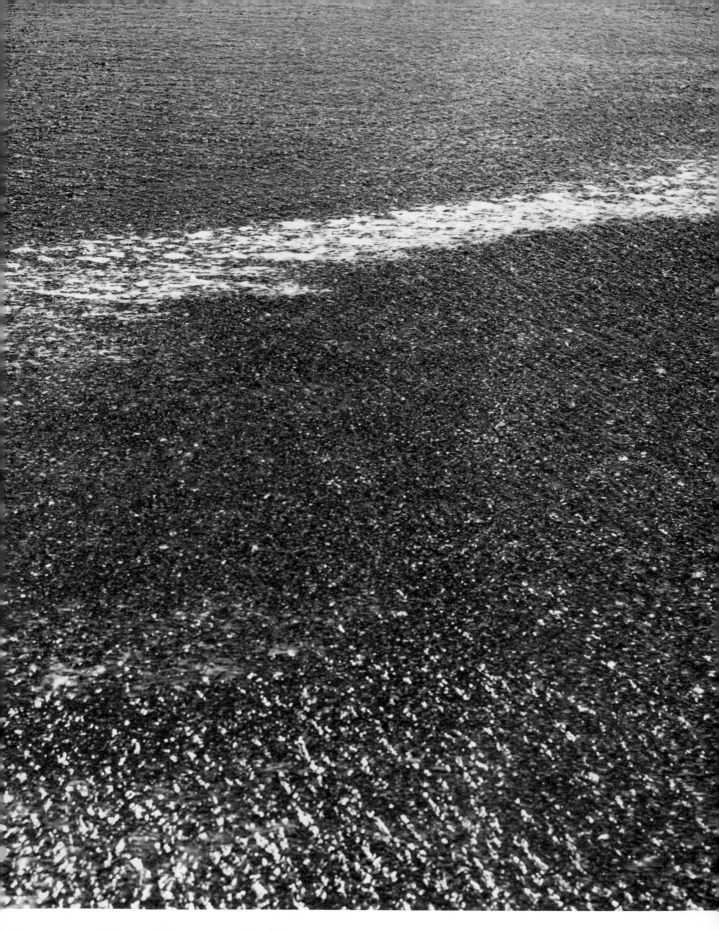

Ocean, shallow water, Florida Keys.
(Rolleiflex; MS pan)

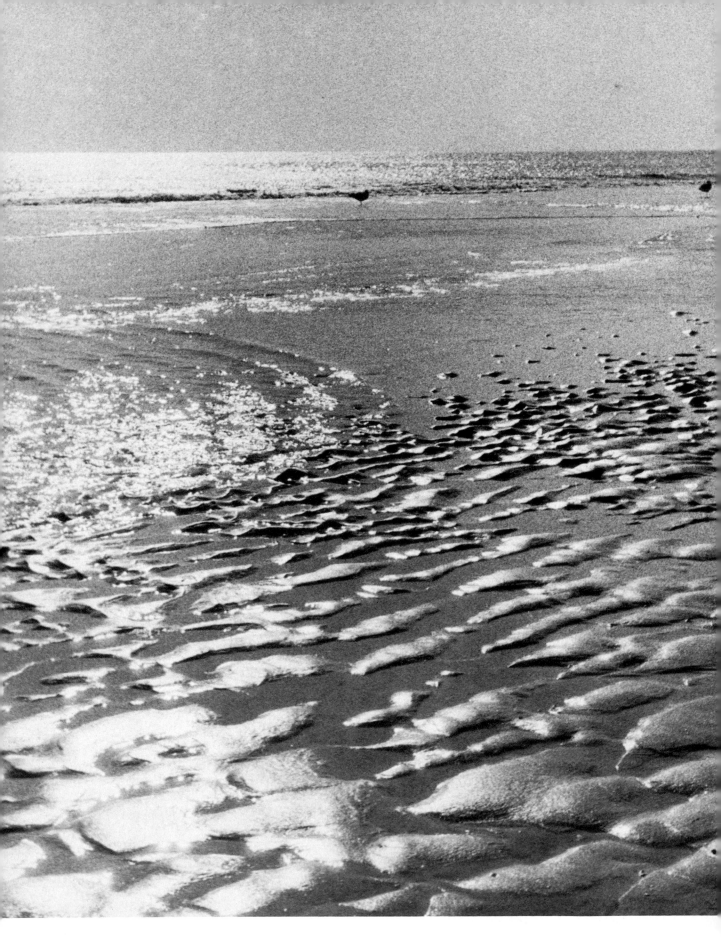

Ocean and beach in winter, Atlantic City, New Jersey.
(Rolleiflex, 4 x 4; MS pan)

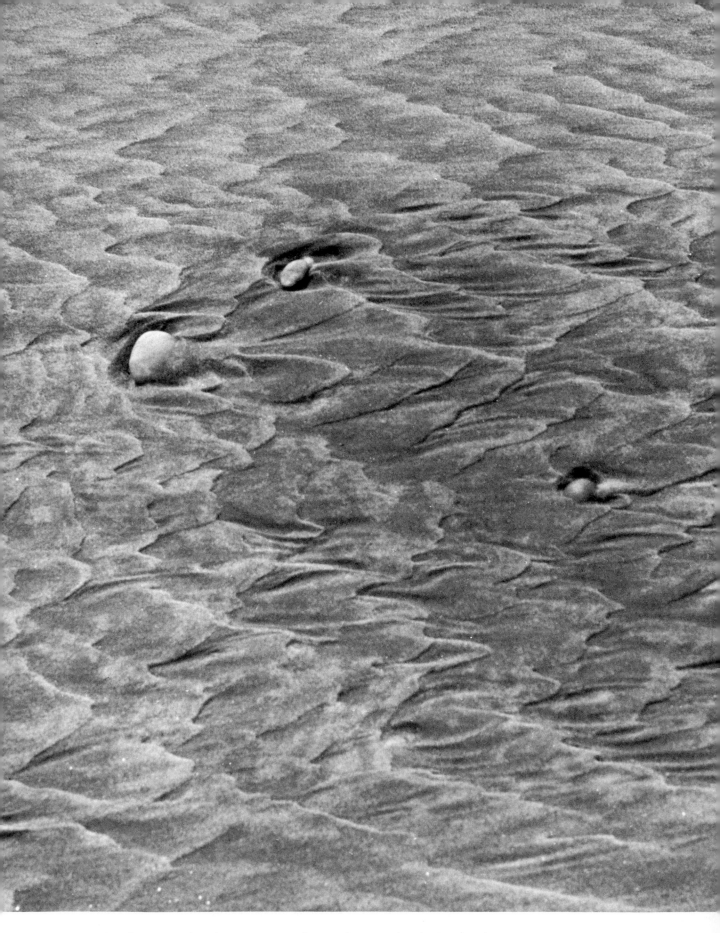

Sand patterns in winter, eastern shore of Long Island, New York.
(Rolleiflex; MS pan)

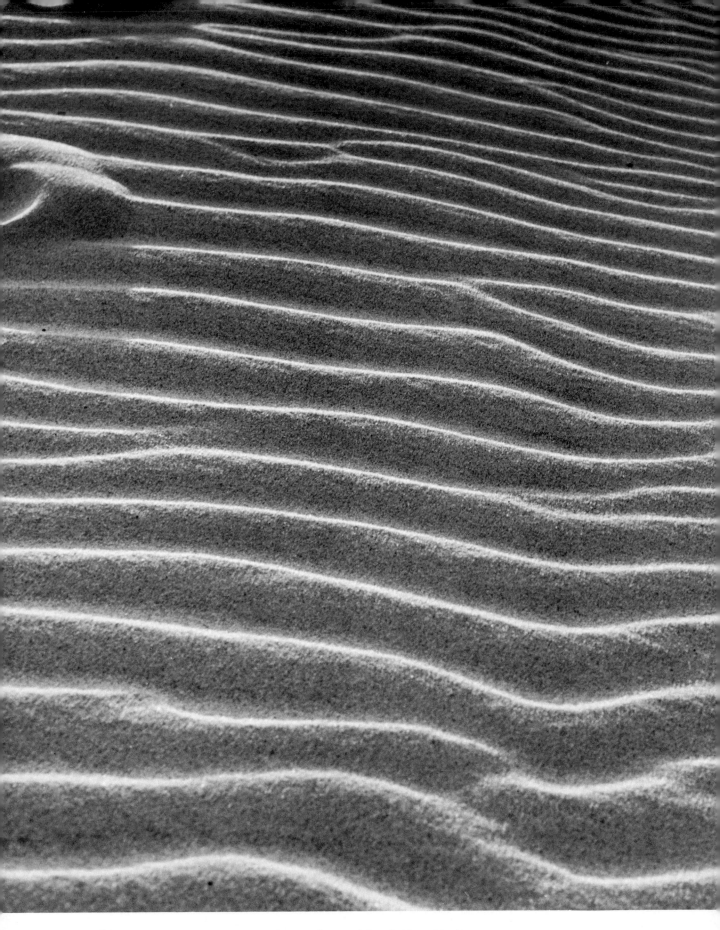

Sand patterns in winter, eastern shore of Long Island, New York.
(Rolleiflex; MS pan)

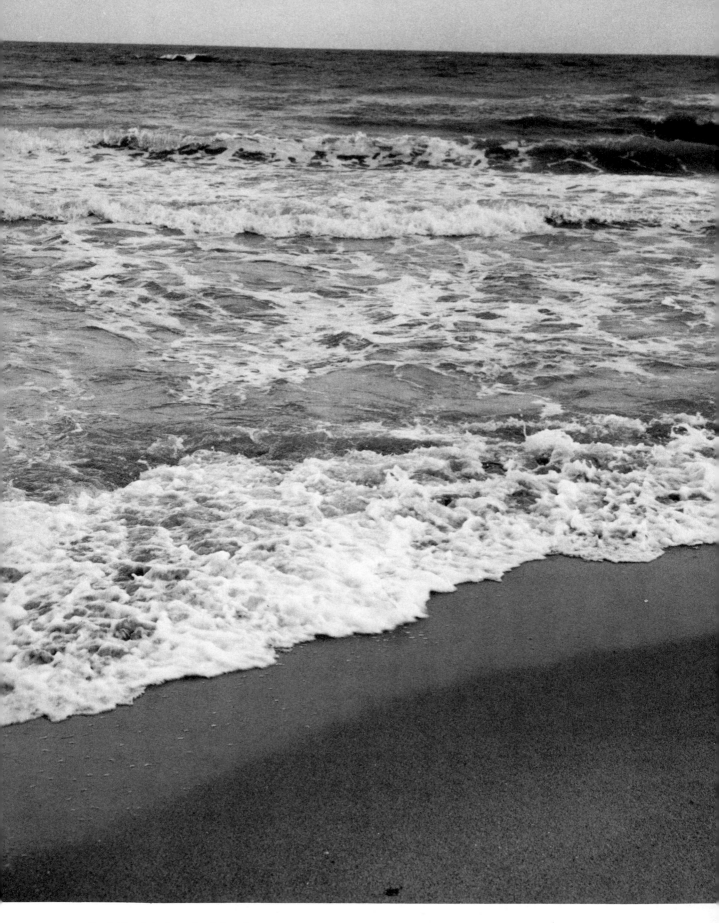

Surf, Florida beach, Atlantic.
(Rolleiflex; MS pan; Pola)

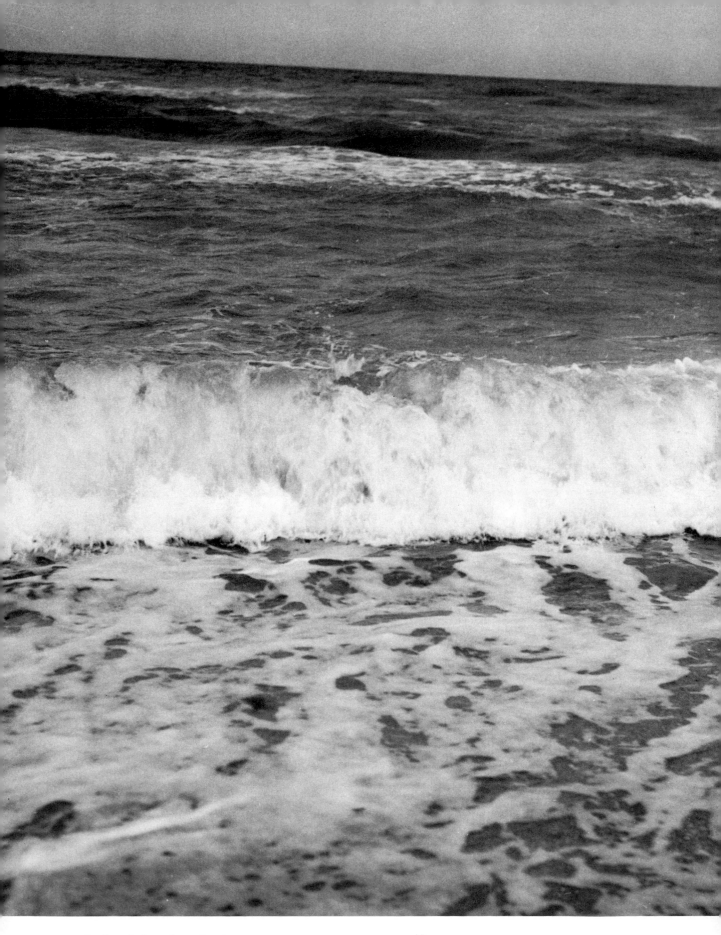

Surf, Florida beach, Atlantic.
(Rolleiflex; MS pan; Pola)

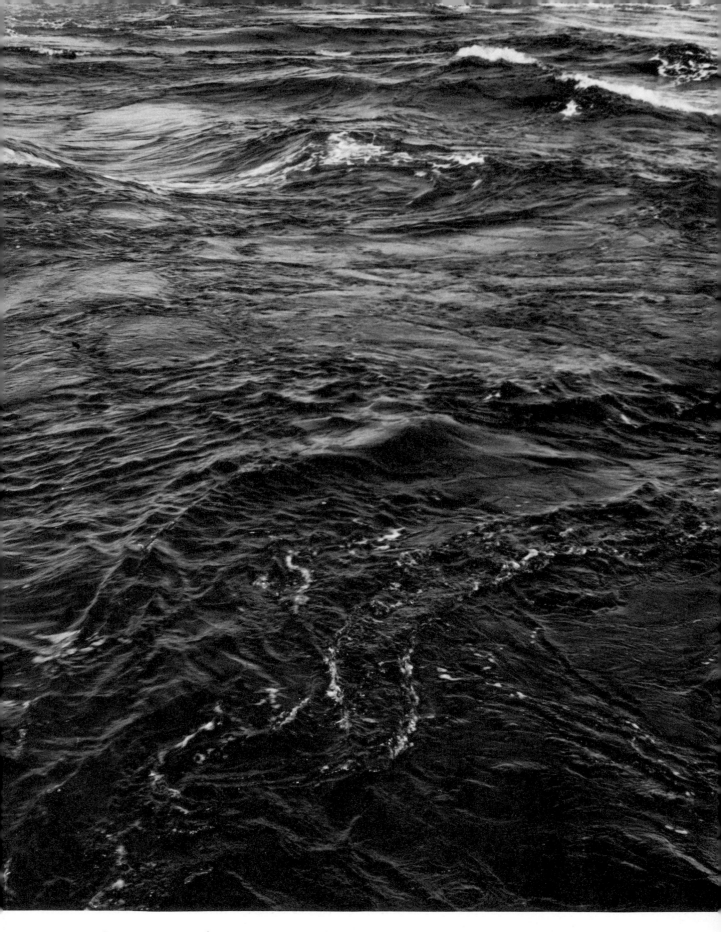

Cross currents, Atlantic Ocean, Florida.
(Rolleiflex; MS pan; Pola)

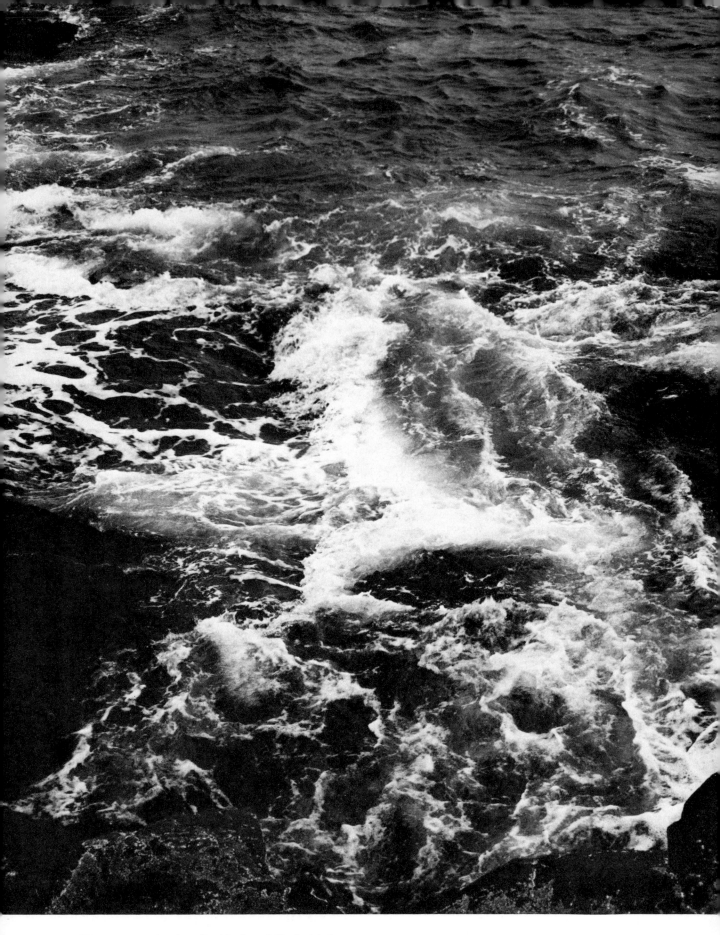

Cross currents, Acadia National Park, Maine.
(Rolleiflex; MS pan; Pola)

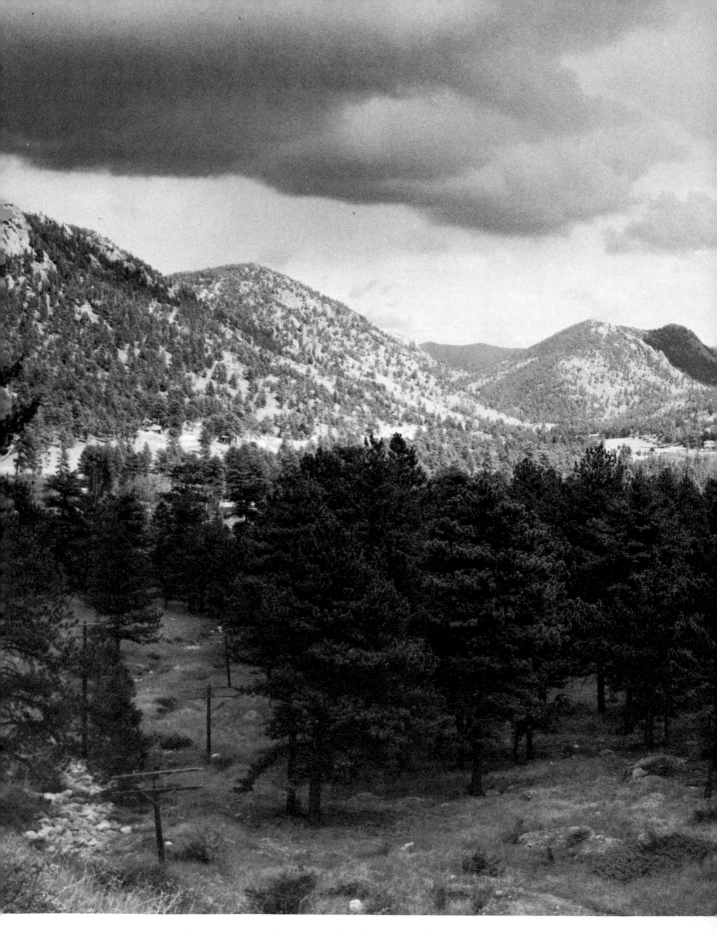

Mountainscape, Rocky Mountain National Park, Colorado.

(Sinar; infra red)

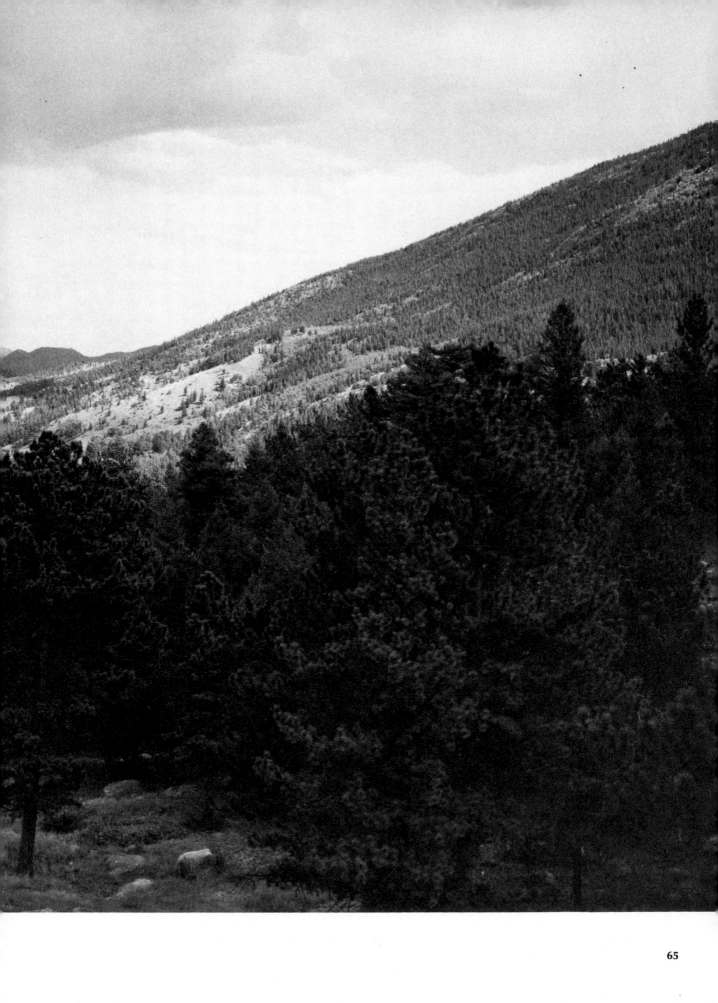

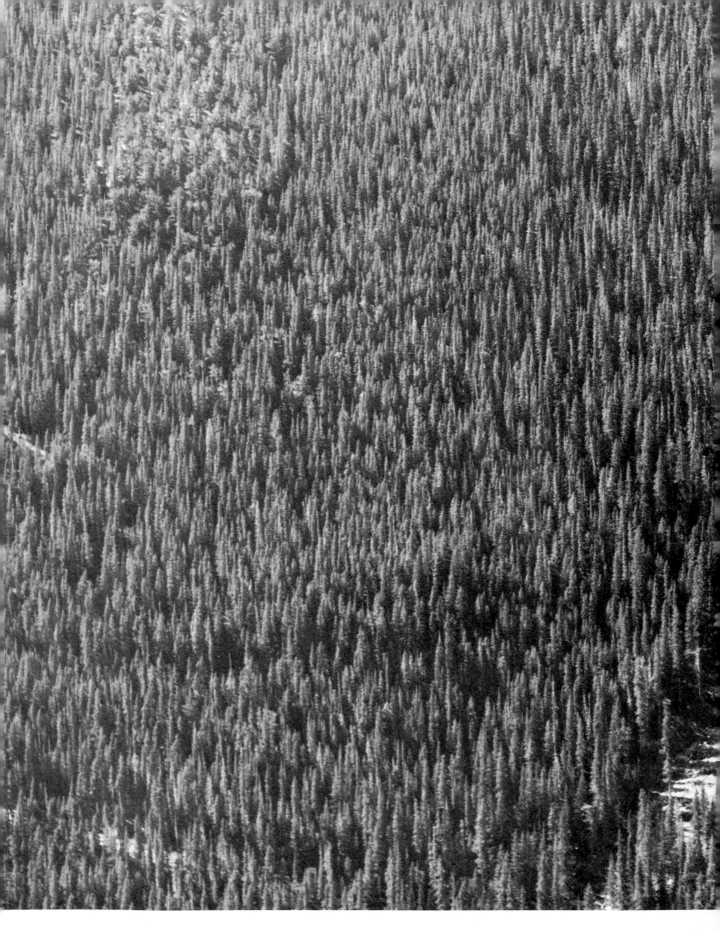

Mountainside of evergreens, Rocky Mountain National Park, Colorado.
(Sinar wide; MS pan)

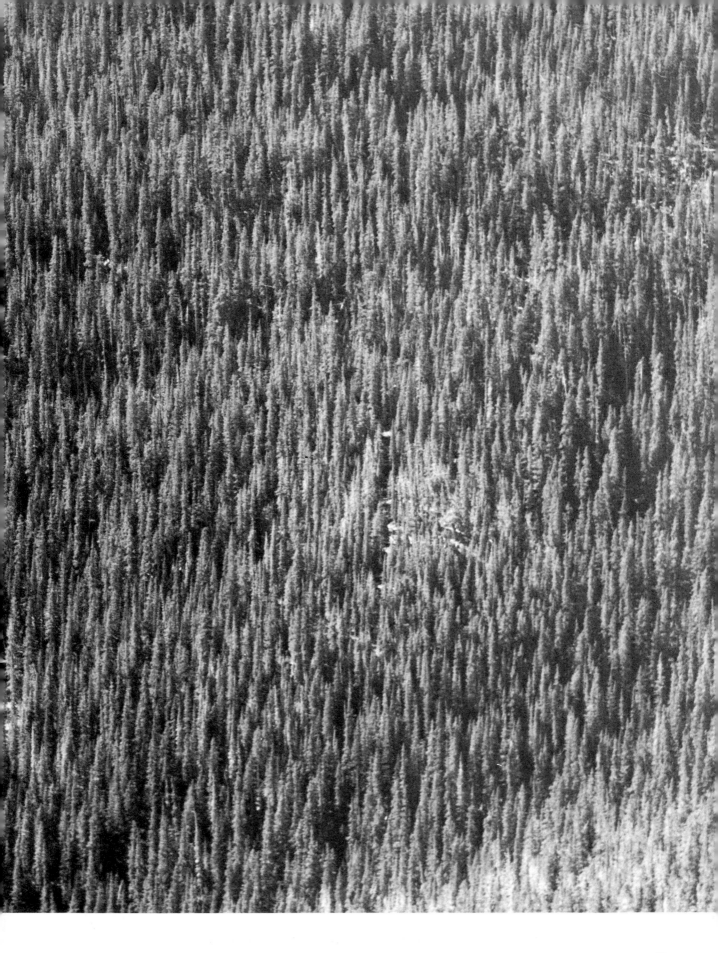

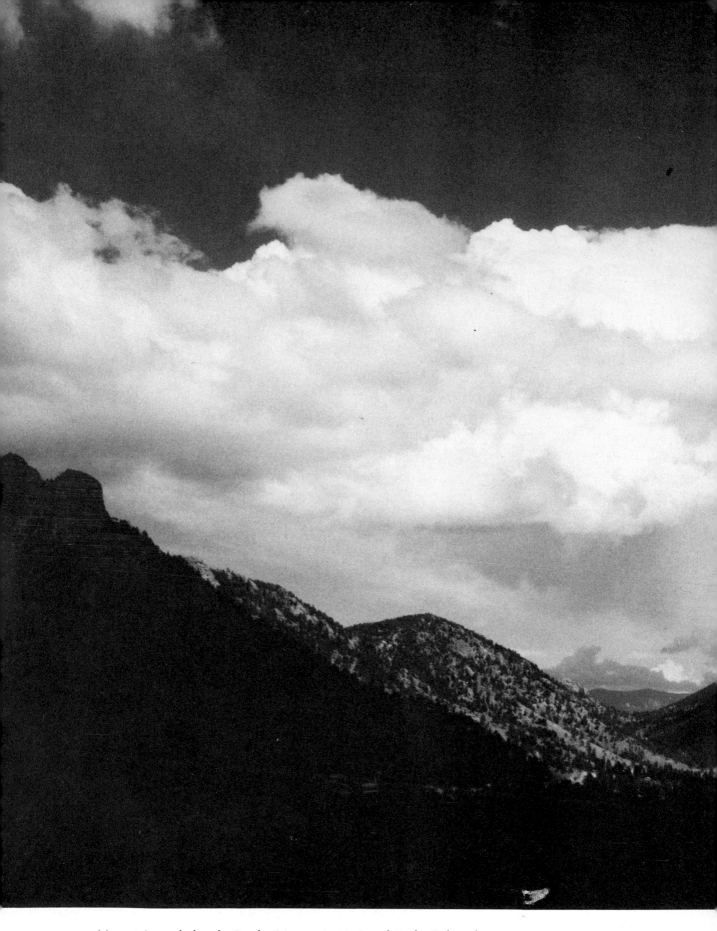

Mountain and clouds, Rocky Mountain National Park, Colorado.
(Sinar wide; infra red; #29 red)

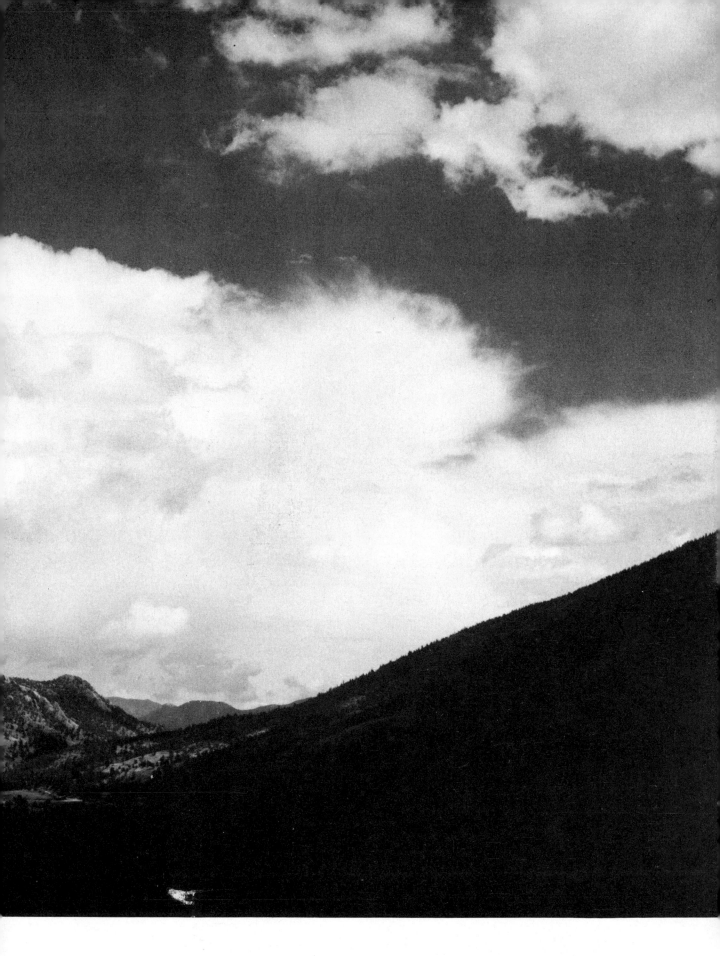

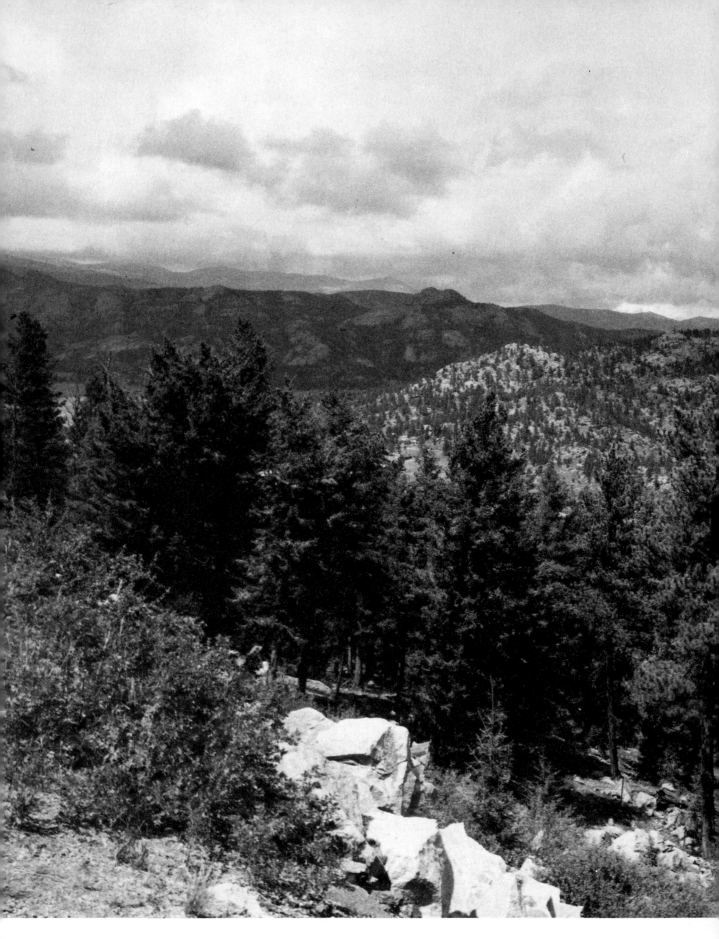

Mountainscape at the timberline, Rocky Mountain National Park, Colorado.
(Sinar wide; MS pan; Pola)

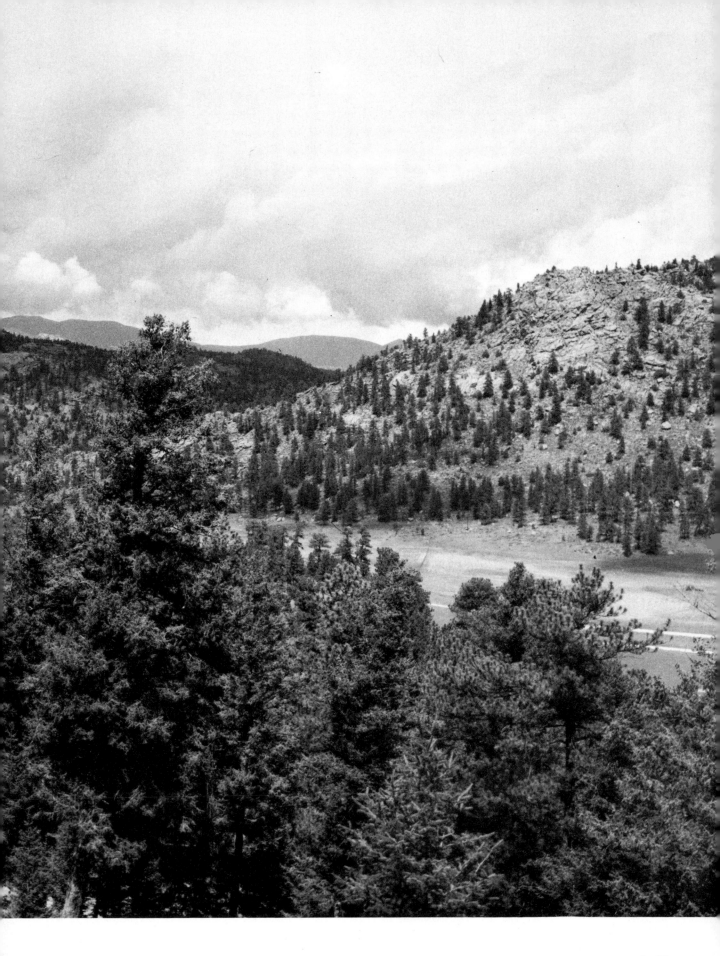

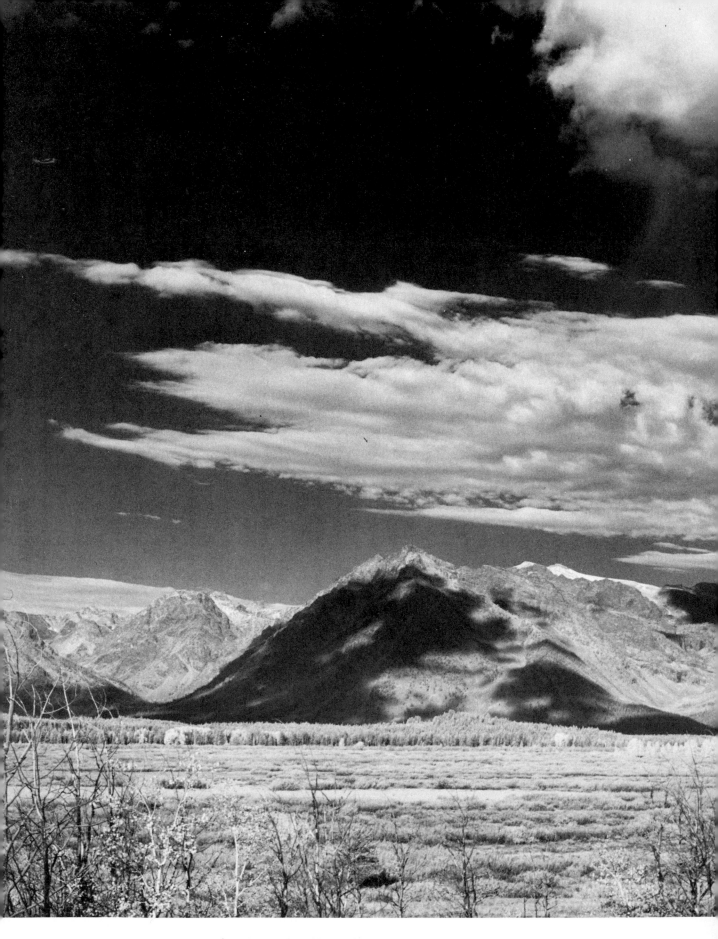

Mountainscape, Rocky Mountains, Wyoming.
(Sinar wide; infra red; #29 red)

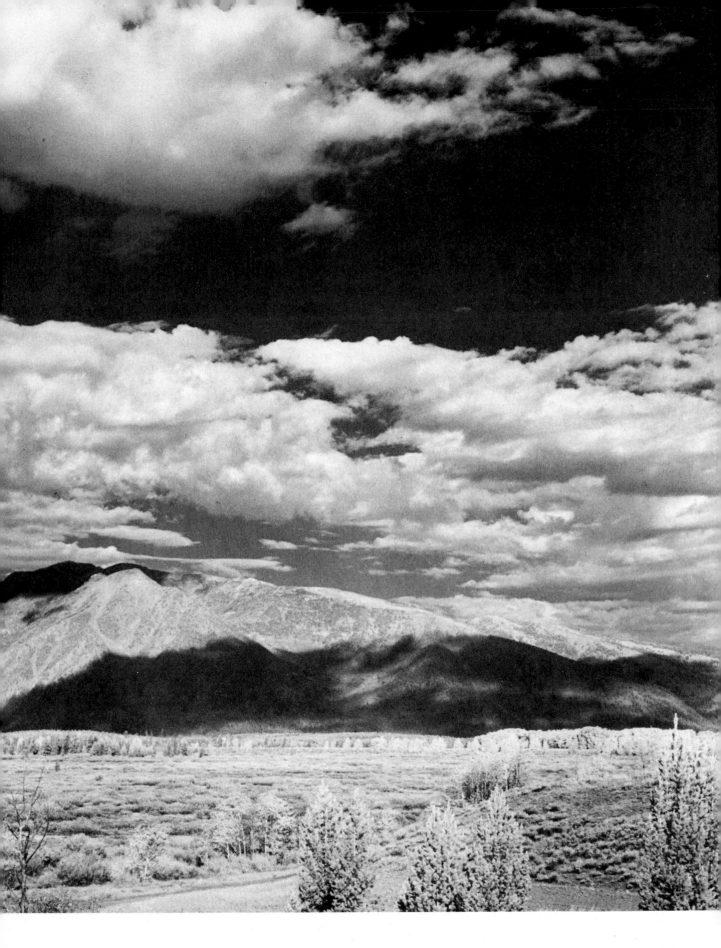

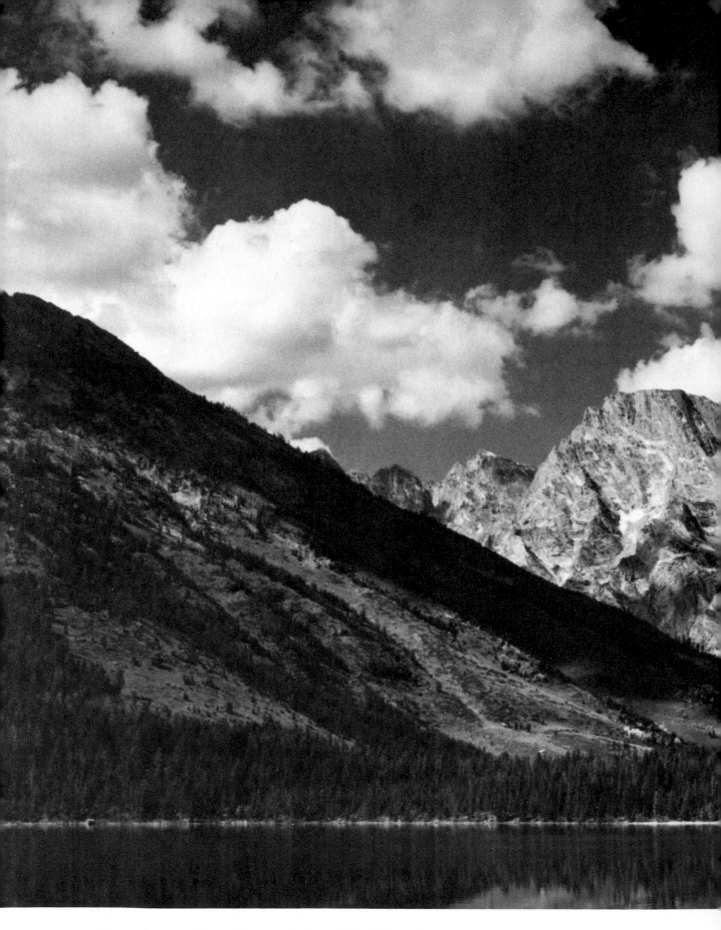

Mountainscape, Grand Tetons, Jackson Hole, Wyoming.
(Sinar wide; MS pan; #25 red)

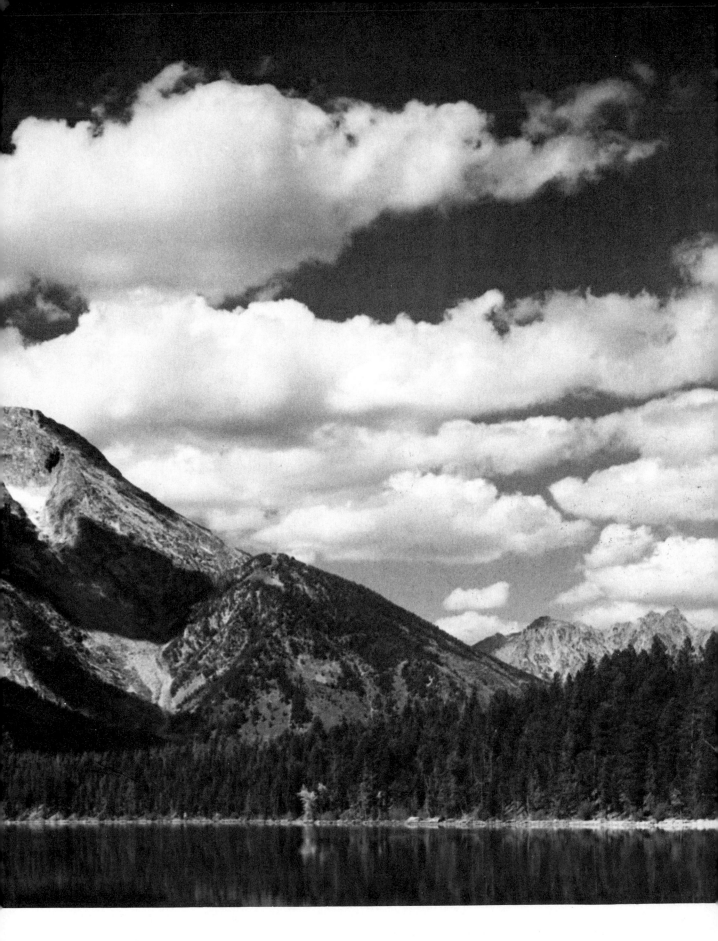

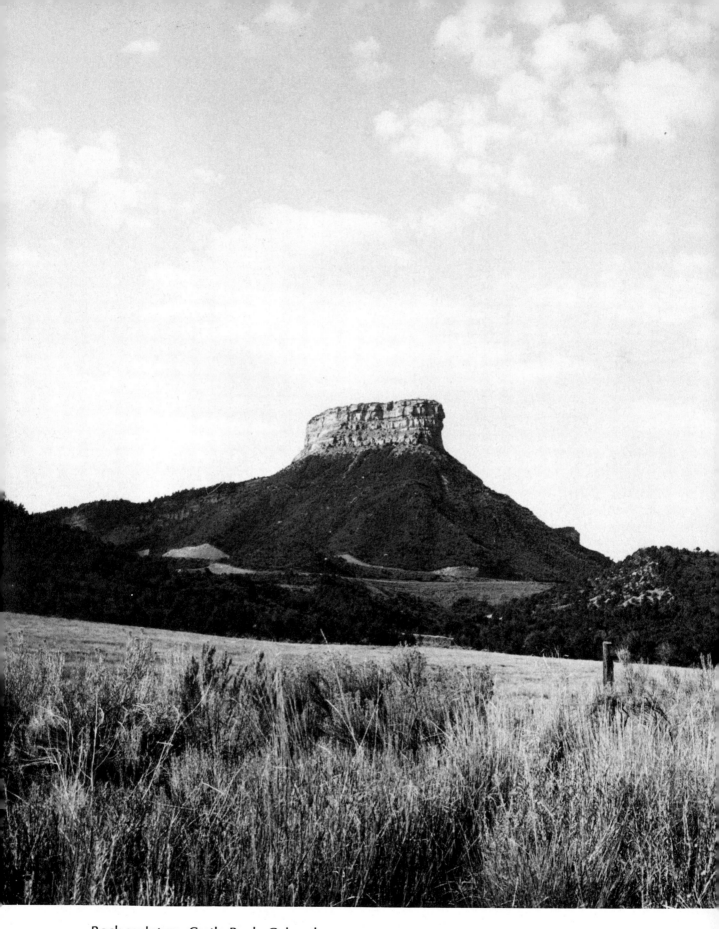

Rock sculpture, Castle Rock, Colorado.
(Rolleiflex; MS pan; #12 yellow)

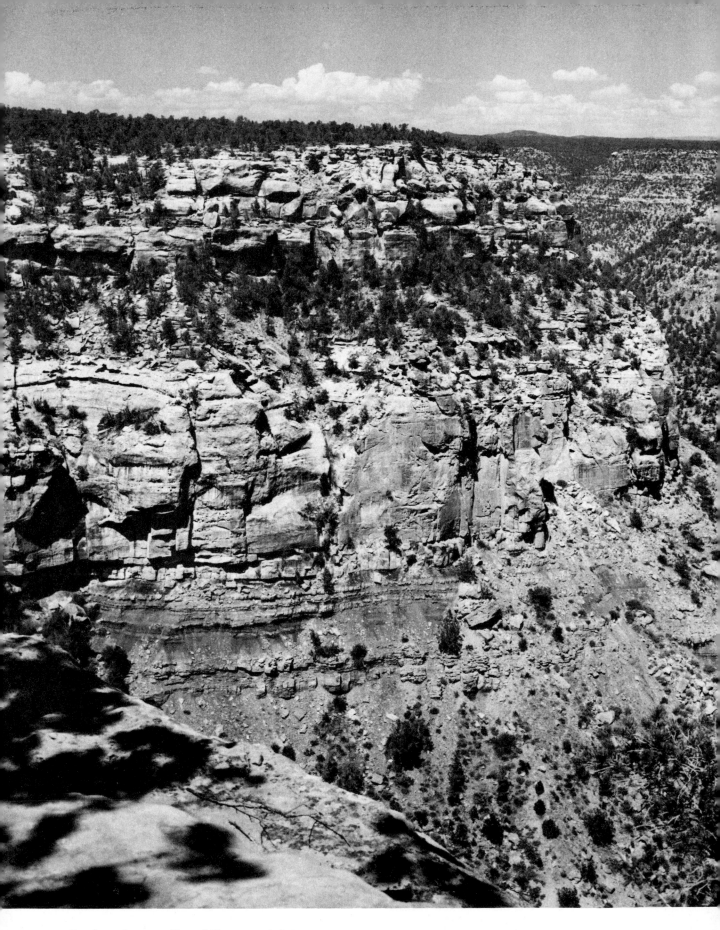

Rock sculpture, Grand Canyon, Arizona.
(Rolleiflex; MS pan; Pola)

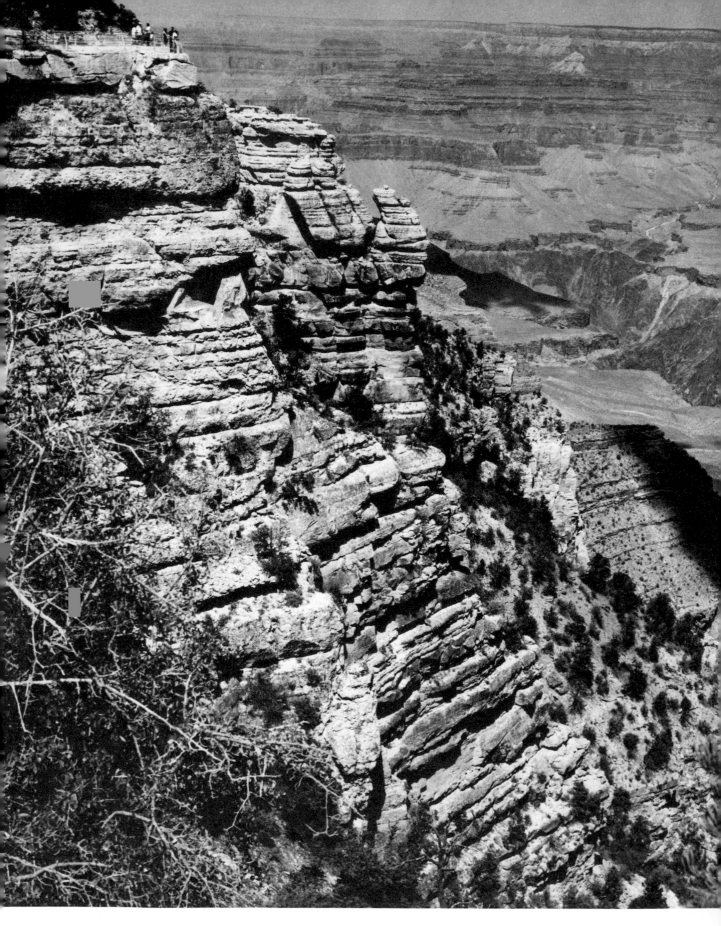

Rock sculpture, Grand Canyon, Arizona.
(Rolleiflex; MS pan; Pola)

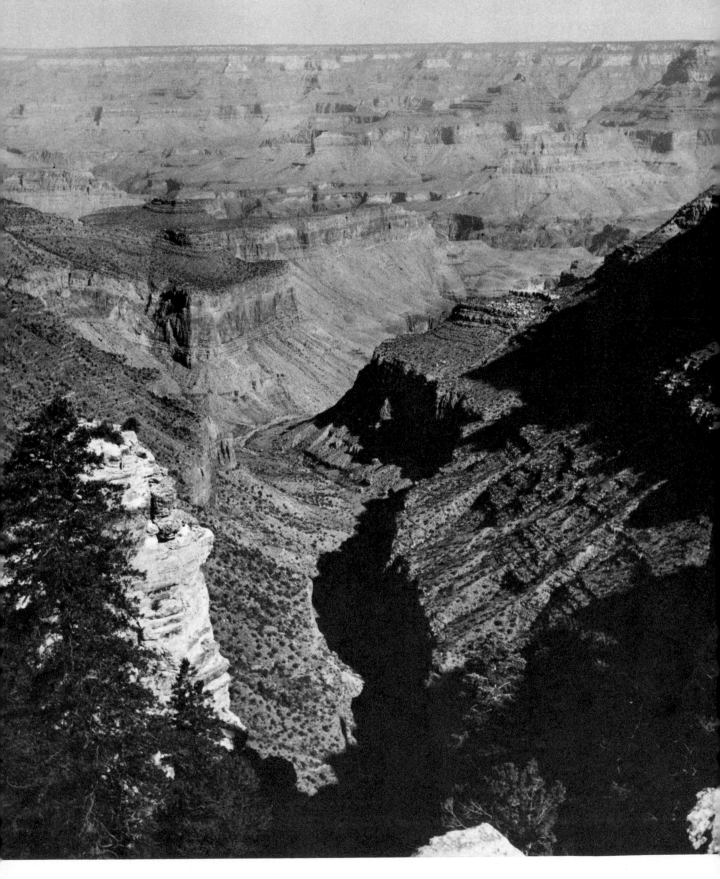

Rock sculpture, Grand Canyon, Arizona.
(Rolleiflex; MS pan; Pola)

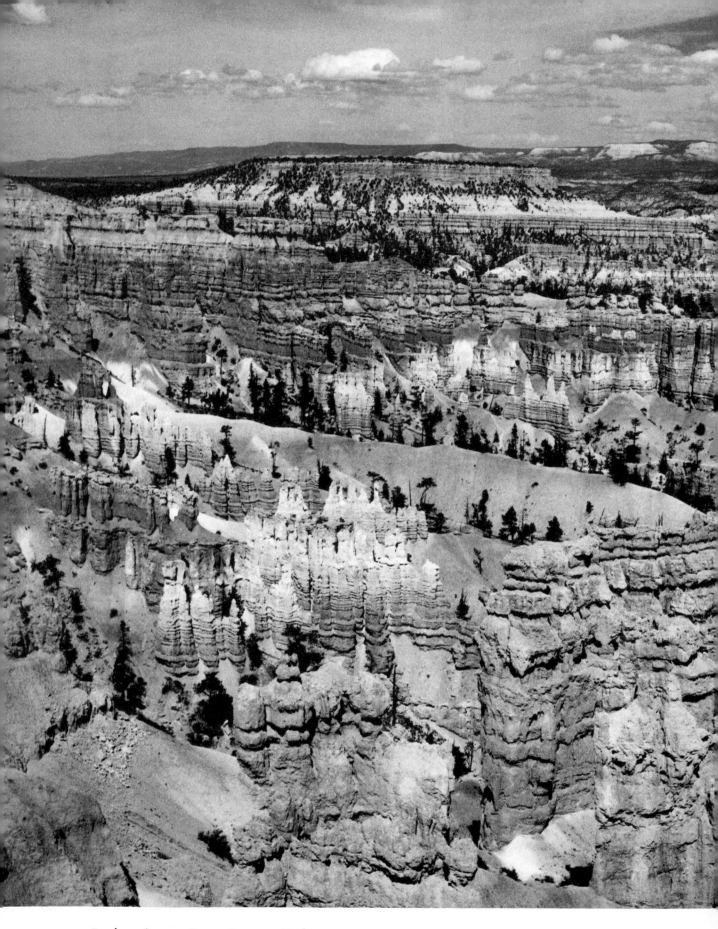

Rock sculpture, Bryce Canyon, Utah.
(Rolleiflex; MS pan; Pola)

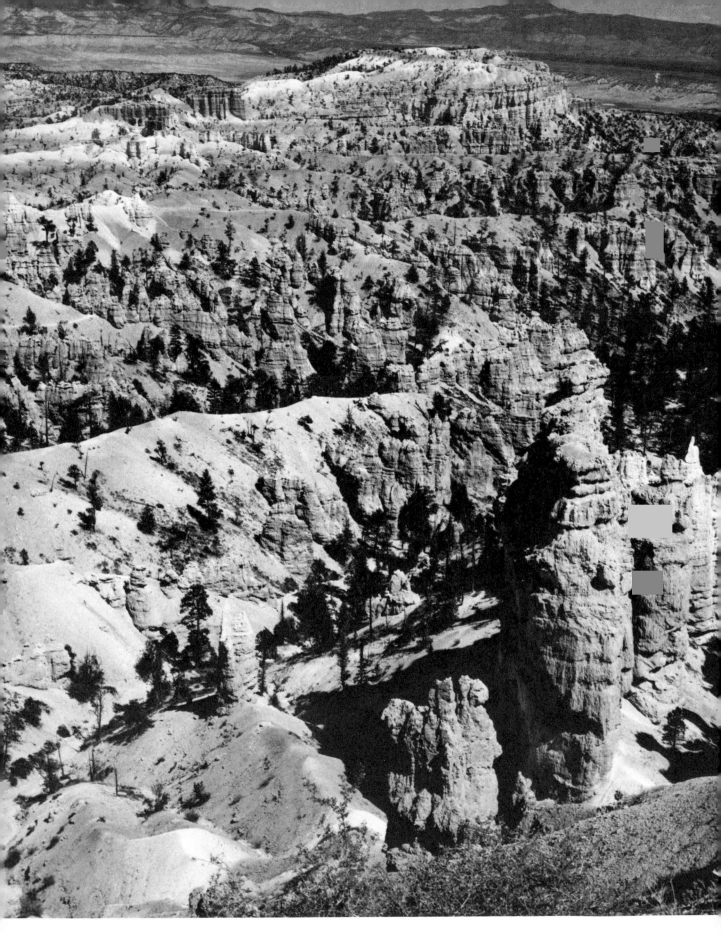

Rock sculpture, Bryce Canyon, Utah.
(Rolleiflex; MS pan; Pola)

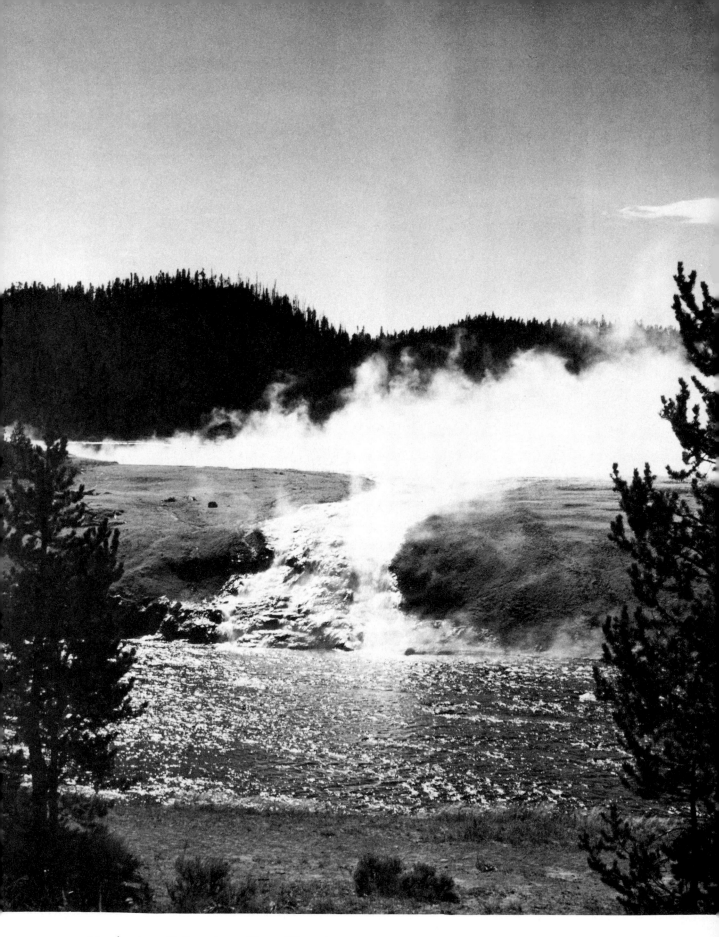

Headwaters, Yellowstone River, Wyoming.

(Rolleiflex; MS pan; Pola)

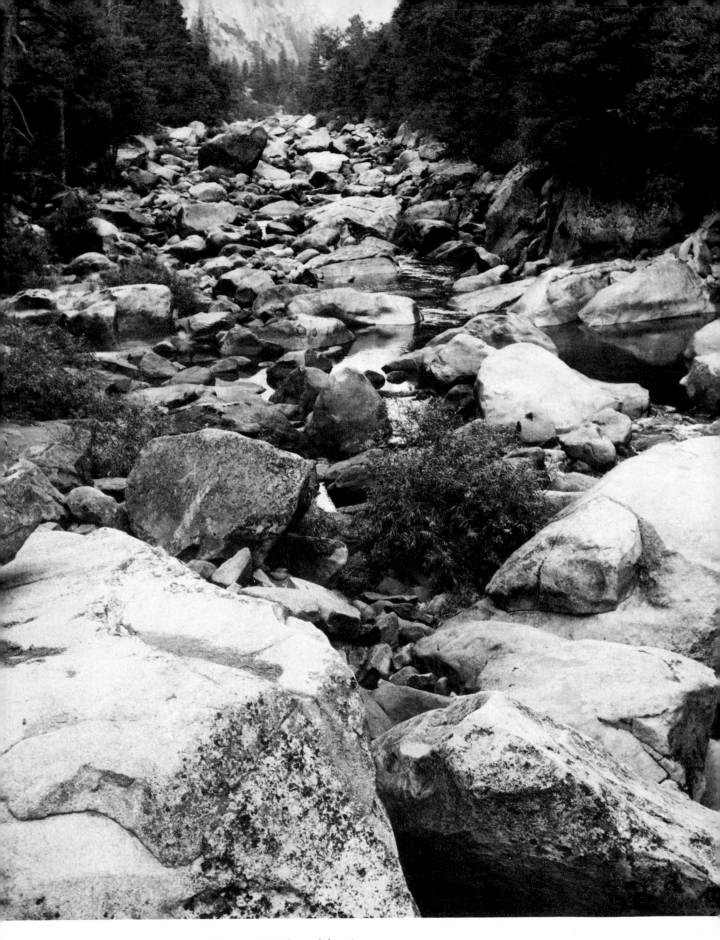

Headwaters, Yosemite National Park, California.
(Rolleiflex; MS pan)

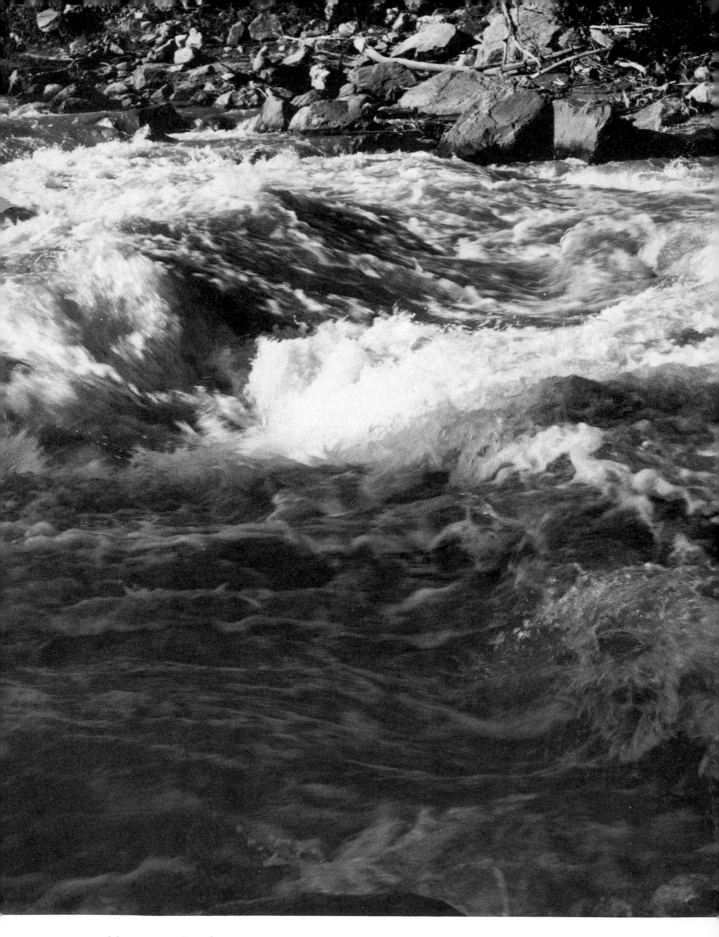

Wild water, Colorado.
(Rolleiflex; MS pan)

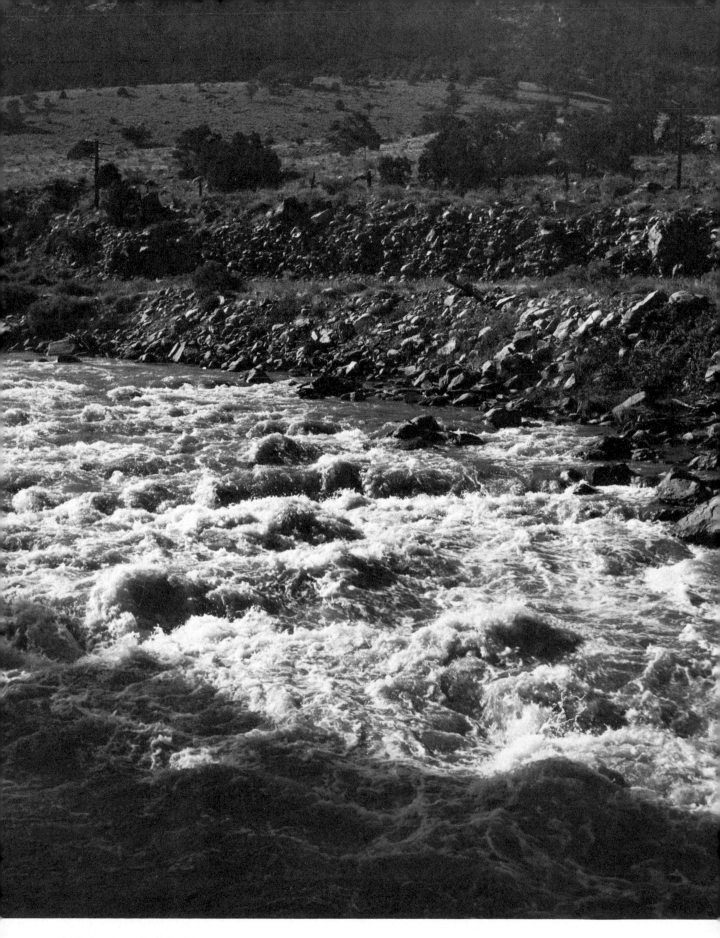

Wild water, Colorado.
(Rolleiflex; MS pan)

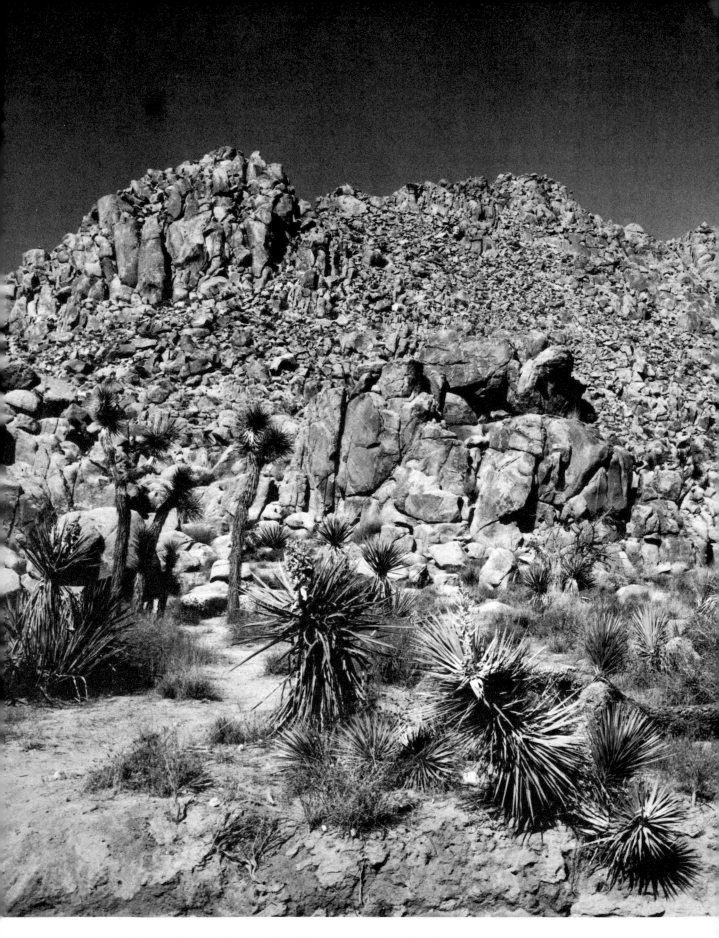

High desert, Joshua Tree National Monument, California.
(Rolleiflex; MS pan; Pola)

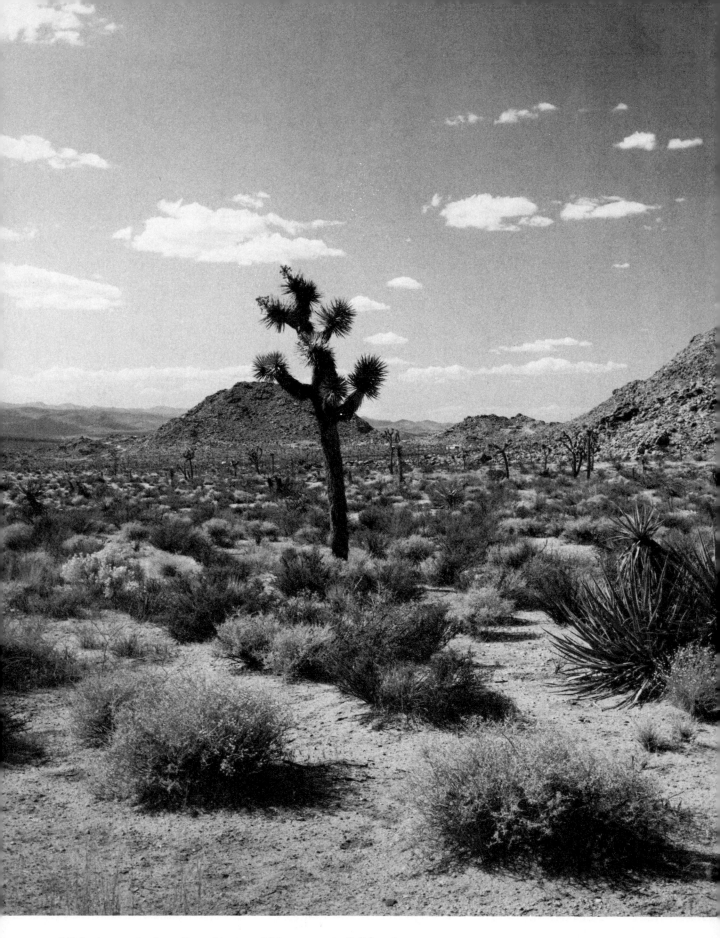

High desert, Joshua Tree National Monument, California.
(Rolleiflex; MS pan; Pola)

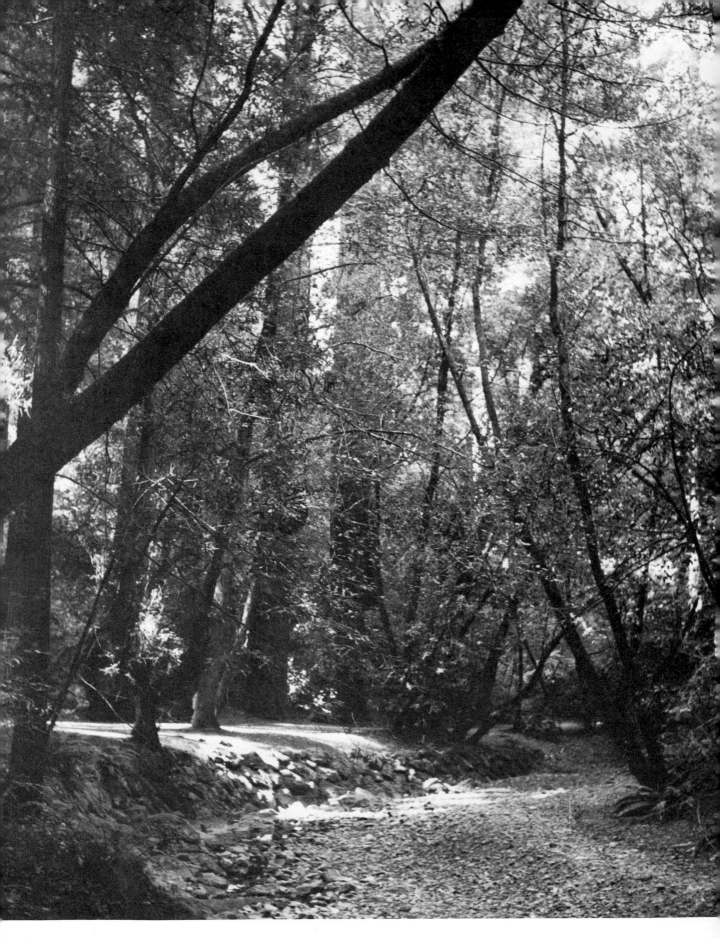

Redwood grove, Big Sur, California.
(Rolleiflex; MS pan)

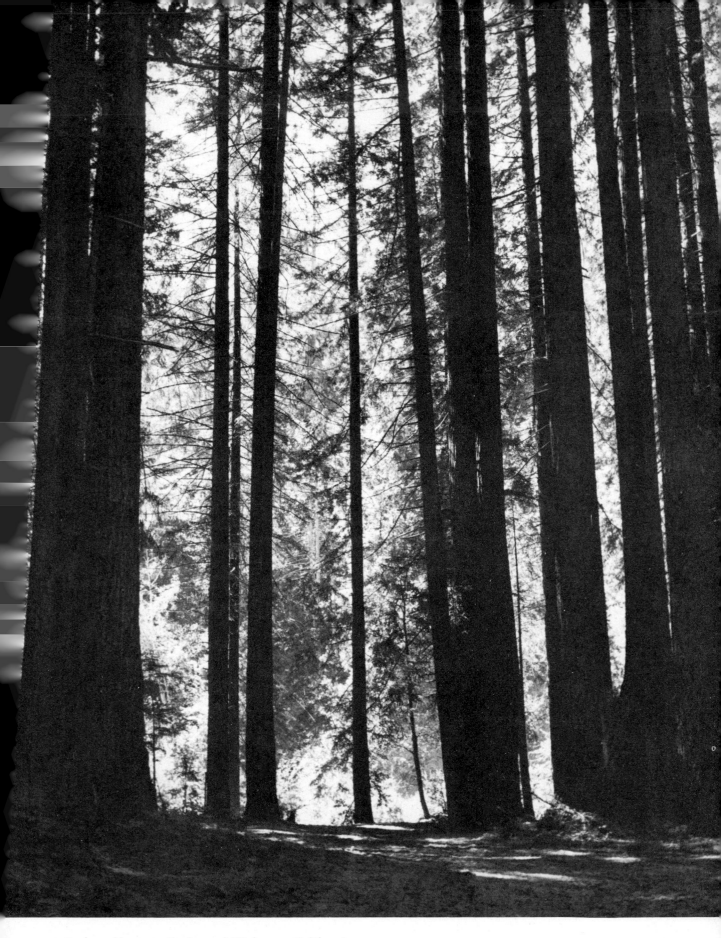

Redwood grove, Redwood Highway, California.
(Rolleiflex; MS pan)

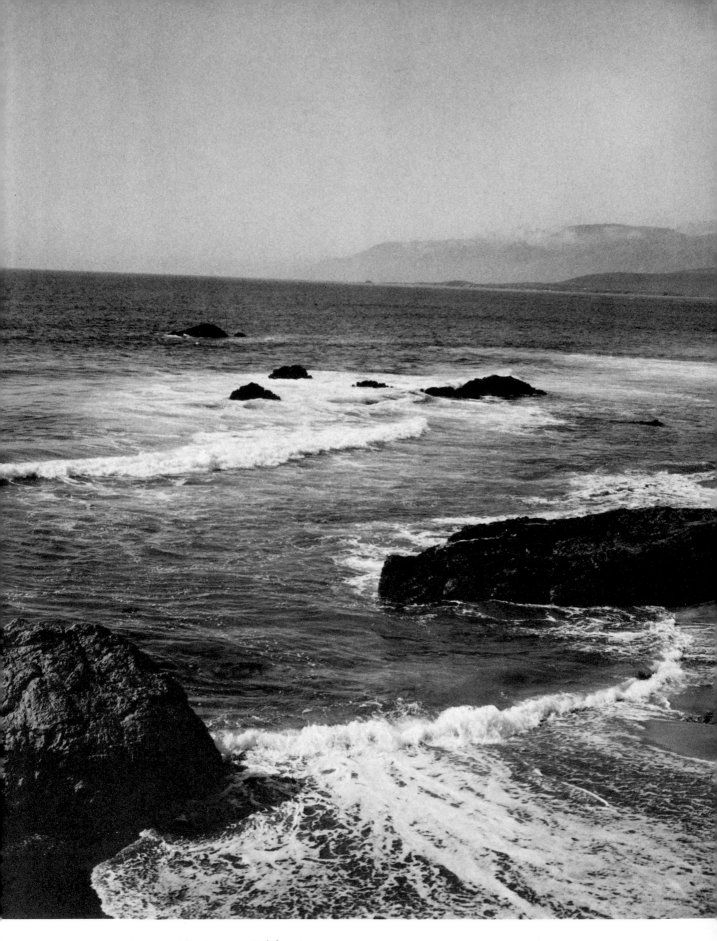

Coastline, Pacific Ocean, California.
(Rolleiflex; MS pan; Pola)

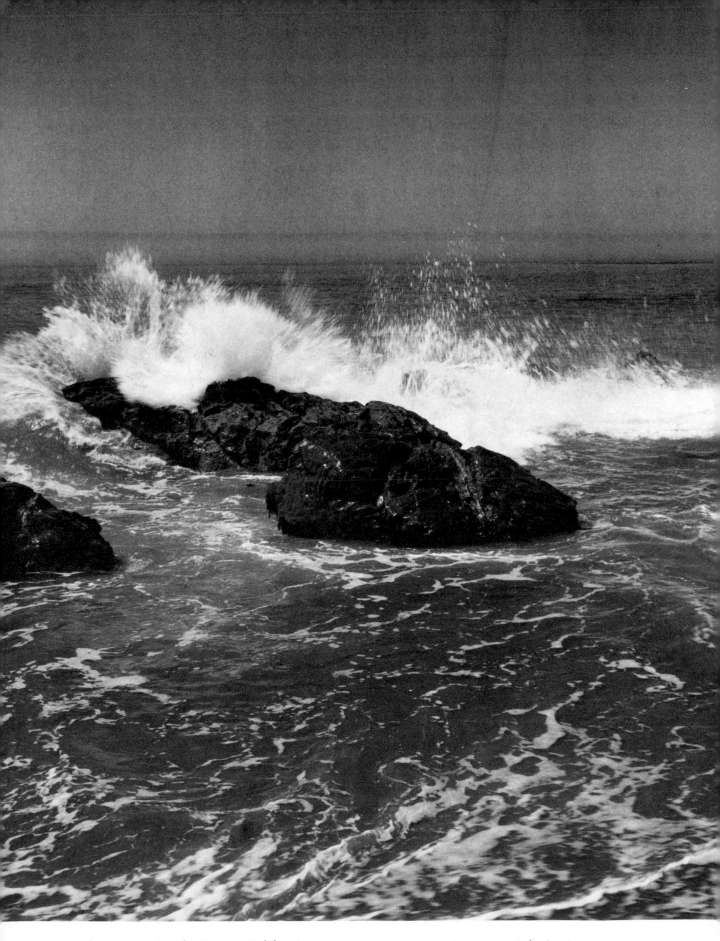

Surf on stone, Pacific Ocean, California.
(Rolleiflex; MS pan; Pola)

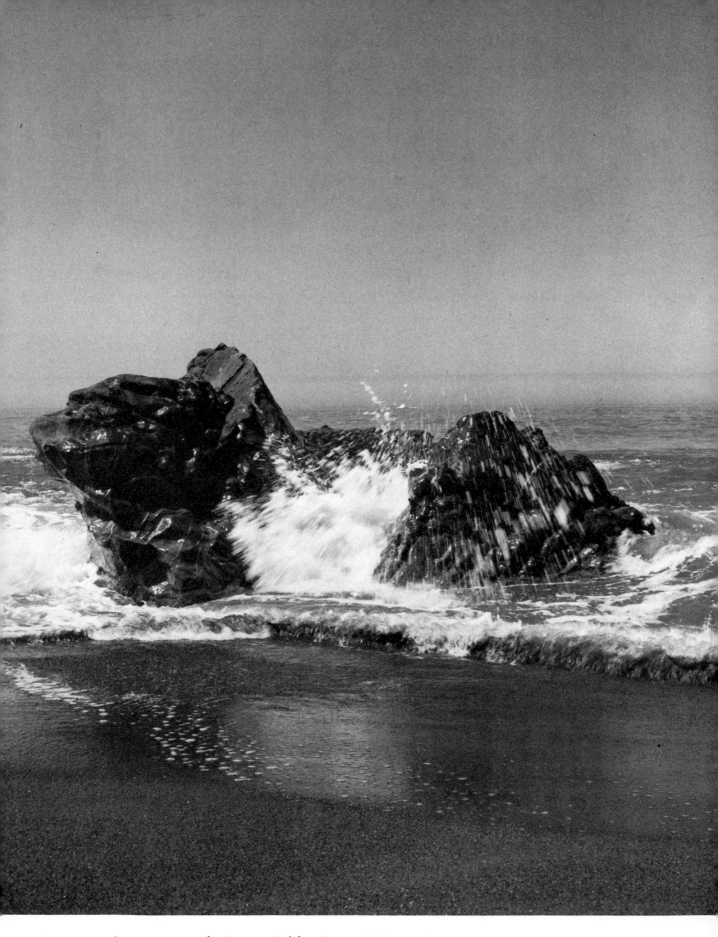

Surf on stone, Pacific Ocean, California.
(Rolleiflex; MS pan; Pola)

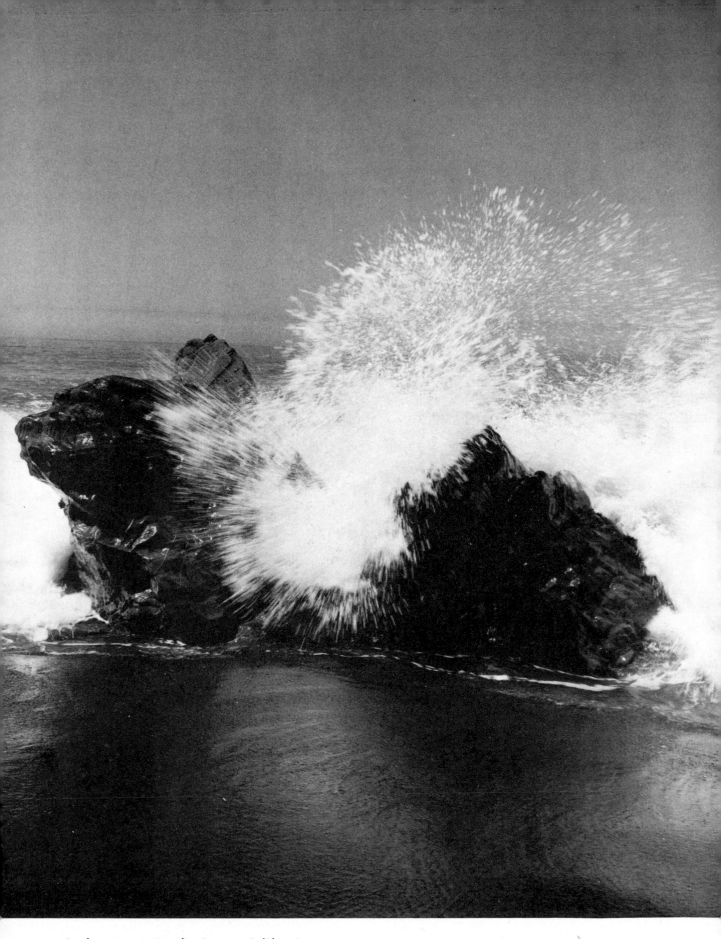

Surf on stone, Pacific Ocean, California.
(Rolleiflex; MS pan; Pola)

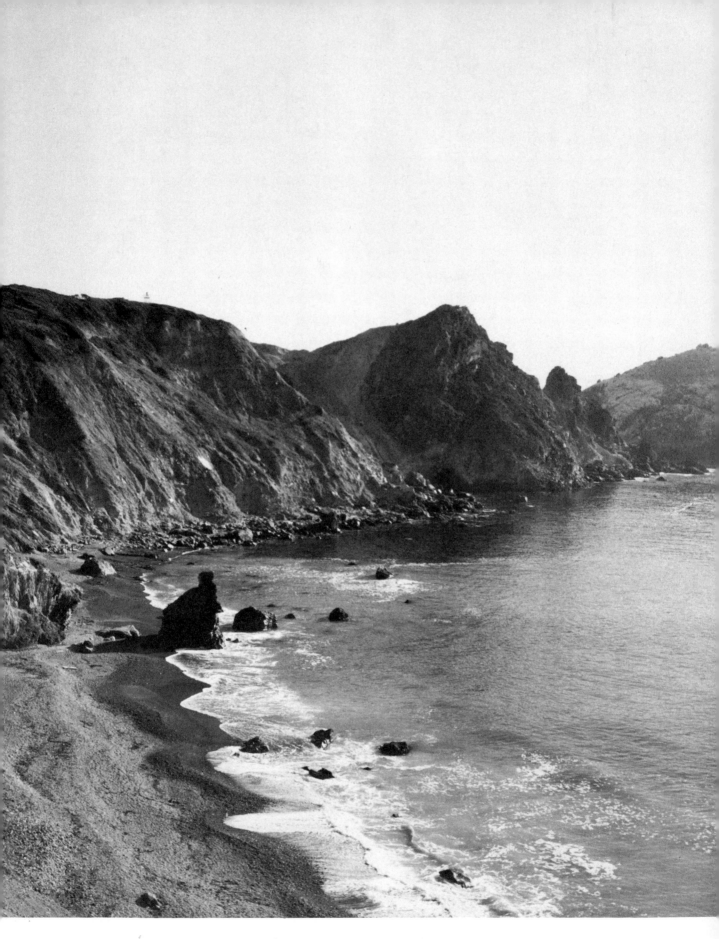

Coastline, Pacific Ocean, California.
(Rolleiflex; MS pan)

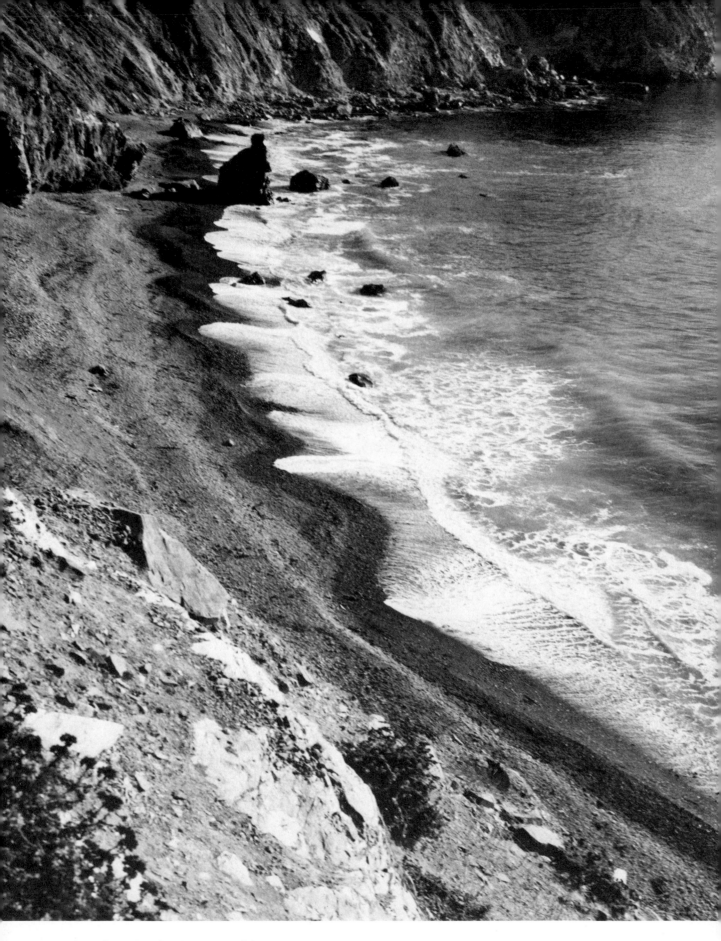

Coastline, Pacific Ocean, California.
(Rolleiflex; MS pan)

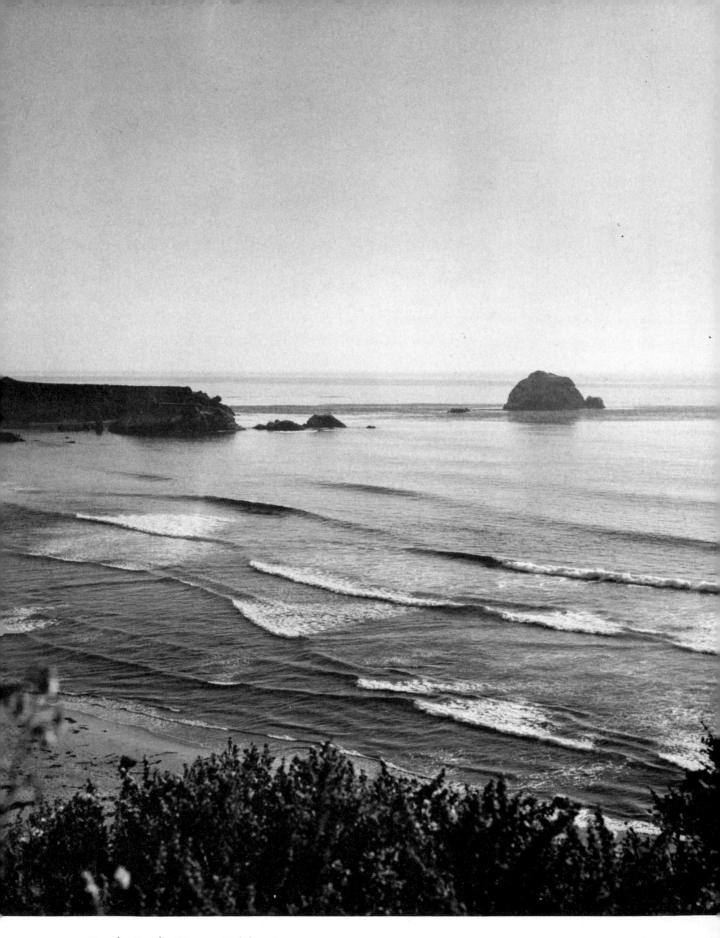

Beach, Pacific Ocean, California.
(Rolleiflex; MS pan; Pola)

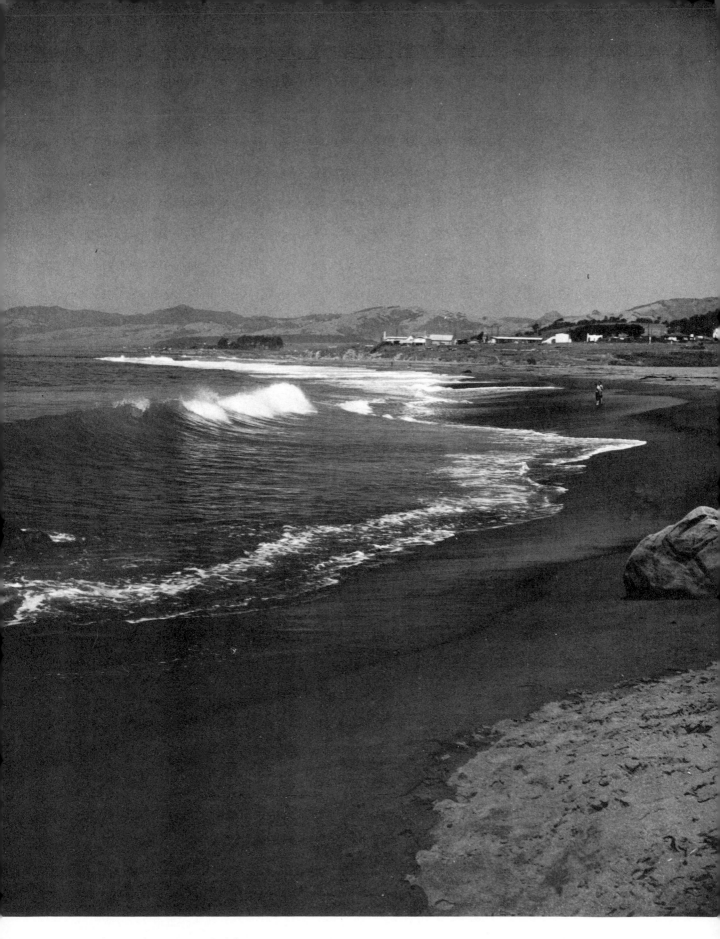

Beach, Pacific Ocean, California.
(Rolleiflex; MS pan; #25 red)

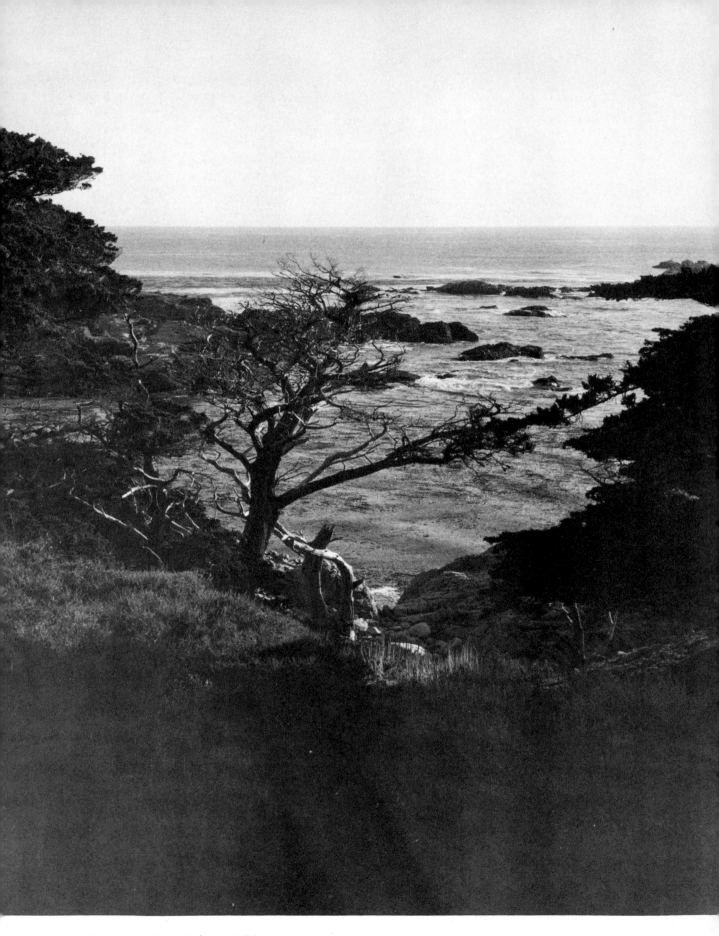

Sunset at Point Lobos, California.
(Rolleiflex; MS pan)

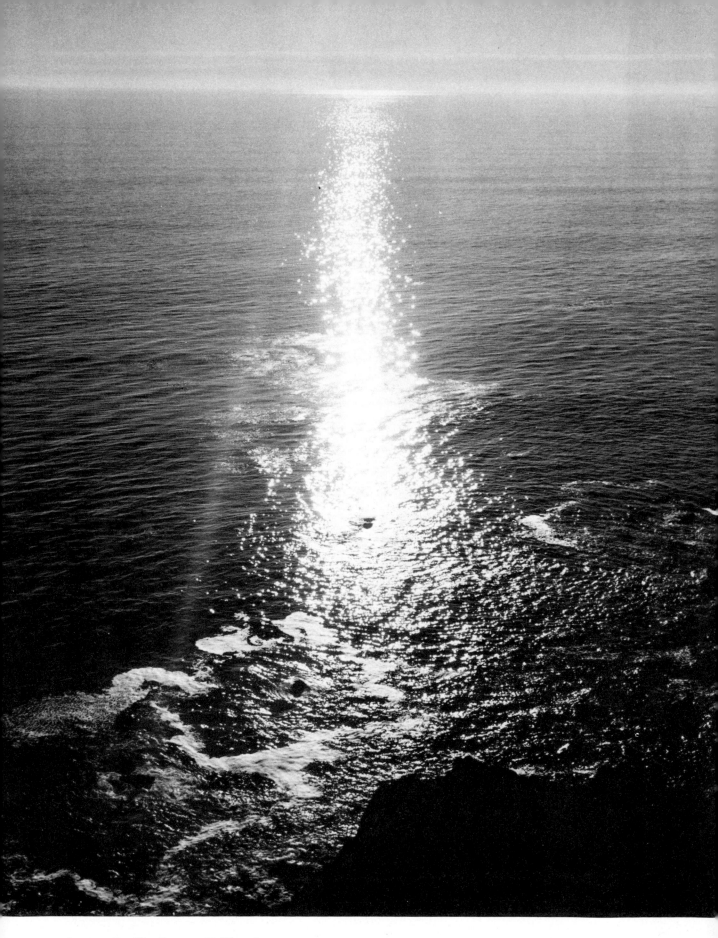

Sunset, Pacific Ocean, California.
(Rolleiflex; MS pan)

INDEX